IMAGES
of America

FRONT ROYAL AND WARREN COUNTY

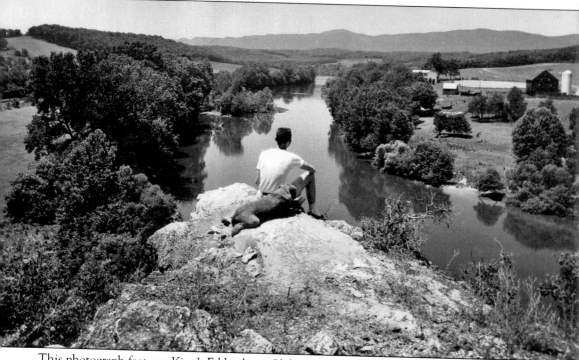

This photograph features King's Eddy above Clifton, with the Isaac Newton King Farm on the right and the Riverview Farm on the left. On the rock is Allen White, son of the photographer, Floyd White.

IMAGES
of America

FRONT ROYAL AND WARREN COUNTY

Thomas Blumer and Charles W. Pomeroy

ARCADIA
PUBLISHING

Published by Arcadia Publishing
Charleston, South Carolina

Printed in the United States of America

Library of Congress Catalog Card Number: 2004103548

For all general information contact Arcadia Publishing at:
Telephone 843-853-2070
Fax 843-853-0044
E-mail sales@arcadiapublishing.com
For customer service and orders:
Toll-Free 1-888-313-2665

Visit us on the Internet at www.arcadiapublishing.com

In Memory of
Mrs. Rhodes
Who suffered a mother's
Greatest sorrow here:
Rose Hill, September 23, 1864

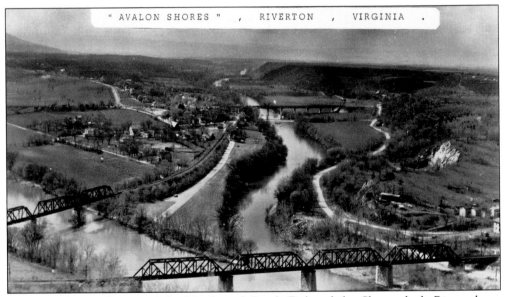

Riverton, the confluence of the North and South Forks of the Shenandoah River, shows Avalon Shores along the left side of the North Fork. The railroad bridges in the foreground and automobile bridges in the background make up the area of the Valley that is referred to as, "The Fork."

4

CONTENTS

ACKNOWLEDGMENTS

The photographs and illustrations that appear in *Images of America: Front Royal and Warren County* have been taken largely from the collection of the Laura Virginia Hale Archives of the Warren Heritage Society. Just before we began to research this book, the *Warren Sentinel* chose the Laura Virginia Archives as the repository for its photograph collection. Although this valuable local history addition has not been processed, we were able to identify several historically important photographs in the collection and include them in this volume. A few photographs were brought in by local citizens and are identified as such in the captions. A fewer number of photographs were taken by present-day photographers, and they too have been identified in the captions. Also, without the archive's paper files, we never could have written the captions.

Without the generosity of the board of the Warren Heritage Society, this book never could have happened. The board gave us full freedom to use the society's photograph collection gathered by Laura Virginia Hale. We had the constant support of our president, Dick Hoover. Board members Dick Hoover and Dr. Lorraine LeHew Hulquist, president elect, reviewed our captions. "At School" was researched and written by Cedar Imboden Phillips. Constant spiritual support and assistance were also provided by our high school docent, Nicole Kahler. A constant stream of patrons of the archives also encouraged us with their enthusiasm.

Although the Laura Virginia Hale Archives is the repository of a rich record of our local history, we often found that we could not depend solely on our paper files, as vast and complete as they are. A countless number of telephone calls, for example, were made to church secretaries and ministers to fill in the blanks in the chapter "Front Royal & Warren County at Prayer." Other calls were made to local businesses and citizens known to be knowledgeable of local history. We would like to thank all these individuals. Listing their names would be exhaustive.

It is my hope and the hope of my archivist assistant, Charles "Chuck" Pomeroy, that this volume will result in a new crop of local historians. Telling the story of Front Royal and Warren County is an ongoing effort. Books and articles telling our amazing story still need to be written, and they may be for the most part researched at the Laura Virginia Hale Archives.

Tom Blumer
Archivist
Laura Virginia Hale Archives
Warren Heritage Society

INTRODUCTION

On the second day God created the dry land, the mountains, and the rivers. He created the Valley of Virginia, and "God saw that it was good." People say He smiled as He surveyed our lush Valley. It is hard to imagine a more beautiful setting than that enjoyed by Front Royal and its surrounding Warren County. It stands on the shores of the legendary Shenandoah River and is neatly tucked in the mountains at the lower end of the Valley.

Today Front Royal has a population of approximately 13,500. The town has recently experienced a rapid growth because of Route 66, which makes travel between the Northern Virginia suburban area and Warren County fast and easy.

Front Royal has a lovely natural setting at the fork of the south and north branches of the Shenandoah River. To the south the Blue Ridge Mountains begin their ascent almost within the town's limits. The 18th-century methods of reaching the area were through Chester Gap from the south and Manassas Gap from the east. Both routes, though not as widely traveled today, retain their dramatic charm and their mountain vistas. Even though most who come to Front Royal take the less scenic Route 66 west, entering Front Royal by Route 522 is more than charming. As one crosses the bridges that span the south and north branches of the Shenandoah, the mountains hang over the town.

The explorer John Lederer viewed the area in 1670 and is credited with being the first white man to feast his eyes on this part of the Valley of Virginia. The frontier, at that time to the east, quickly reached the Shenandoah. In 1673 Lord Culpeper received a royal charter that covered a wide area of Virginia, including the acreage fated to be named Warren County. He opened his land to settlement. During this same period, Cadwallader Jones crossed Chester Gap making a map for Lord Culpeper. In 1689 Lord Fairfax inherited the Northern Neck Proprietary, including the future Warren County, from Lord Culpeper. As Lord Fairfax sold large tracts of land, settlement increased. The first to arrive included the Lewin family, Robert Carter, the Hardings, and the Hurst families. The McKay and Hite families settled here in 1731.

Progress is evidenced by a charter to put a ferry across the Shenandoah granted to Thomas Chester in 1736. Two years later Peter LeHew arrived and in 1754 purchased the 200 acres that would become LeHew Town and eventually Front Royal. During Front Royal's early days it was also known as Hell Town.

In 1785 the name LeHew Town was dropped and Front Royal was chartered.

In 1836, the town was so thickly populated that a new county was formed from Shenandoah County to the west and Frederick County to the northwest. Warren County was born. By 1854 industry had grown in Front Royal to the point where the old ferry was replaced by wooden bridges spanning both branches of the Shenandoah River. That same year railroad service came to Front Royal.

In 1861 Virginia seceded from the Union, and the men of Front Royal and surrounding Warren County almost to a man joined the Confederate States Army. In 1862 the invading Union Army occupied Front Royal for the first of six times. Some months before, 16-year-old Belle Boyd had been sent from the war zone around Martinsburg to the safety of Front Royal. Instead of settling into a quiet life, she was determined to become an official Confederate spy. She began her intelligence career in Belle Boyd Cottage. Through her efforts, Gen. Stonewall Jackson was able to take Front Royal with a lightning speed that was unusual even for him. However, by the end of the war, not one business remained in Front Royal. Following the burning of the Valley of Virginia, people faced starvation.

Following the nearly total destruction caused by the invading Union Army, Front Royal began a slow climb out of wartime poverty. The Carson family began to produce lime in 1868, and the *Warren Sentinel* began publishing its weekly paper in 1869. The railroad, destroyed during the war, resumed operation in 1873, giving industry a tremendous boost. By the 1890s, Front Royal experienced booming conditions.

The 20th century was kind to Front Royal. Early in the century, Remount Depot was constructed. Today its old military character replaced by the Smithsonian's Conservation and Research Center. In the 1930s the Shenandoah National Park was established. Today thousands of tourists visit Front Royal to begin a scenic journey south along the Skyline Drive. In the late 1930s the Skyline Caverns were discovered and developed. The caverns are situated between Front Royal and the Skyline Drive.

Twentieth-century industry in Front Royal was dominated by American Viscose, which eventually changed its name to Avtex. For many years Front Royal was also home to the Old Virginia Packing Company. These two industries employed a large percentage of Front Royal's work force for many years.

Most of the photographs found here have been taken from the collections of the Warren Heritage Society's Laura Virginia Hale Archives. The society was organized in 1971, with the express purpose of educating local citizens about the long history of this area. In 1980 the society took possession of Ivy Lodge to house its history. In 1982, the society obtained the Belle Boyd Cottage and had the building moved from its original location, off Main Street, to Chester Street. The next few years were consumed by restoring the cottage and constructing an archive building to its rear. The grand opening of the Laura Virginia Hale Archives was held in 1986. Today a visit to the archives is a must for anyone doing local history and genealogy work in the Warren County area.

One

FRONT ROYAL AND WARREN COUNTY AS GEOLOGICAL GEMS

One of the primary reasons for visiting Front Royal is to take in the natural beauty of the area. The Shenandoah River cuts through the center of Warren County and is good for boating. To the west, the county is hemmed in by Massanutten Mountain and to the east by the Blue Ridge. The entrance to the much-visited Skyline Drive is minutes away. The Shenandoah National Park is also an ideal place for those who like to hike, camp, and just enjoy the natural beauty of our forested land. All to be seen is not on the surface, however, as the Valley of Virginia is also visited for its caverns. The Skyline Caverns is located south of Front Royal beyond the entrance to the Skyline Drive.

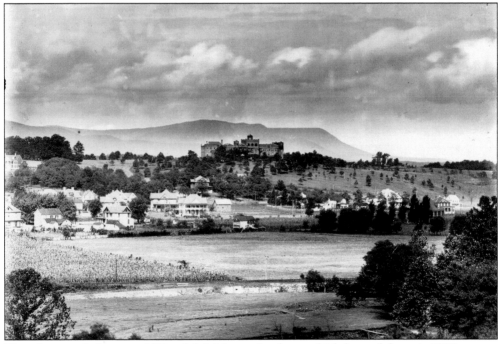

This photograph features old Randolph-Macon Academy, which burned down in 1927, as seen from Bel Air. Massanutten Mountain is situated in the background, with Happy Creek, the railroad, pasture, and North Royal Avenue houses in the foreground.

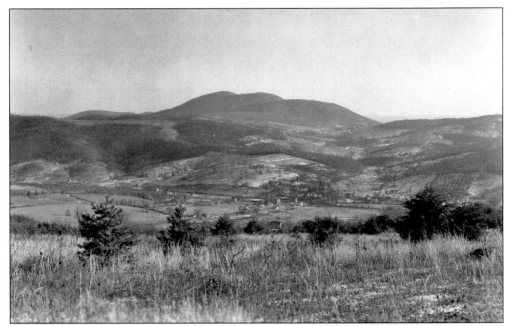

This image offers a view of Linden, *c.* 1954. Linden is now a weekend community with about 500 homes that run along both sides Interstate 66, at exit 13. Through this area, known as Manassas Gap, the first railroad to Front Royal was built. It is the home of Freezeland Orchards and Alpenglow sparkling cider.

This panoramic view of the Wheeler Maddox farm on the Shenandoah River features in the background the mountains that frame the Valley of Virginia.

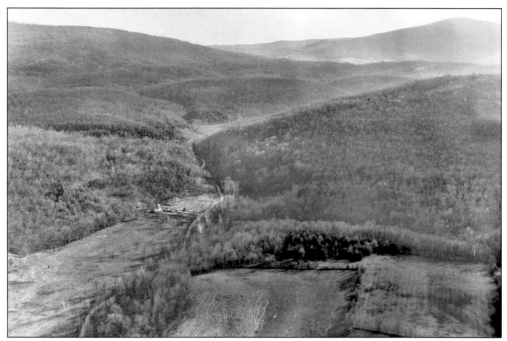

This photo of Manassas Gap, taken by H.J. Burrows, looks to the northwest towards Front Royal. Manassas Gap was used by the first settlers to enter the area.

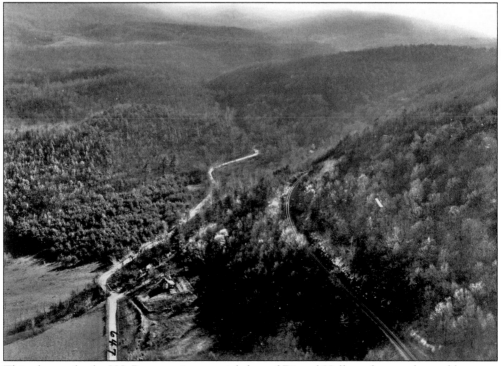

This photo, also by H.J. Burrows, is an aerial shot of Dismal Hollow, the area located between Riverton and Linden. The area is dominated by Route 66, which extends from Northern Virginia to the Valley and ends at the Route 81 junction.

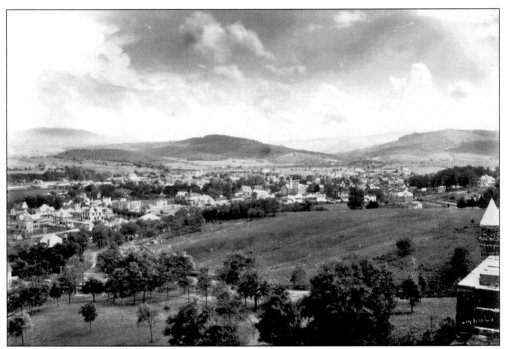

This photograph features a pre-1927 view of Front Royal as seen from Randolph-Macon Academy. The image looks southeast toward Chester's Gap in the Blue Ridge Mountains, the gateway to Rappahannock and Fauquier Counties.

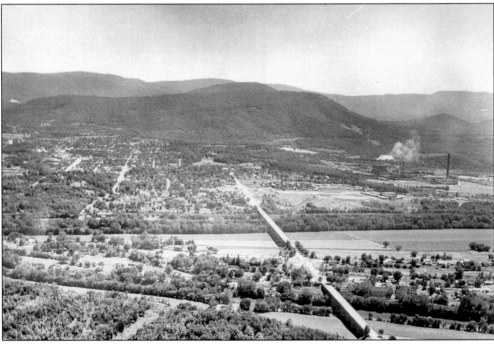

This 1964 aerial view shows Front Royal and Riverton, the narrow bit of land between the two forks of the Shenandoah and between the two bridges. The bridges were built and dedicated in 1941. The Avtex plant smoke stack can also be seen on the right.

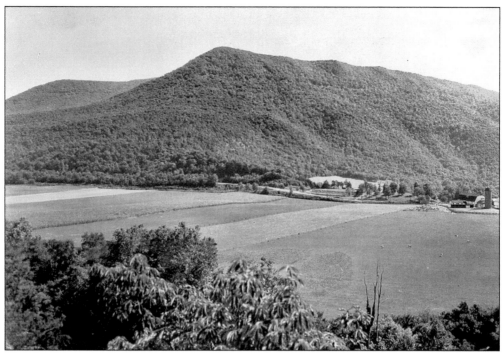

This photo by Frank R. Hupp, c. 1968, features Signal Knob, which is the peak at the lower or northern end of Massanutten Mountain that may be visible from Warren County. It was used to control of the Valley of Virginia during the Civil War. The Confederacy used Signal Knob to communicate between its armies in Northern Virginia and the Valley. Today the summit of Signal Knob is a popular destination for hiking enthusiasts.

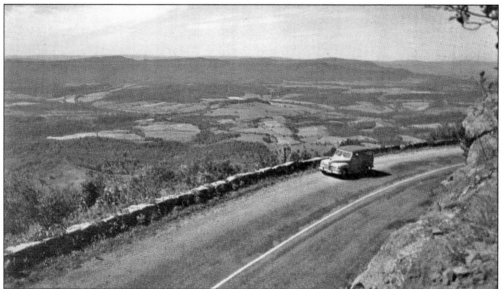

Land for the Shenandoah National Park was purchased by the federal government in 1935. The park was dedicated in 1936 and has been a continual place of recourse for tourists ever since. Hiking trails and camping areas are scattered across the park. The less adventurous tourists tend to remain in their cars and stop at one of the numerous overlooks along the Skyline Drive.

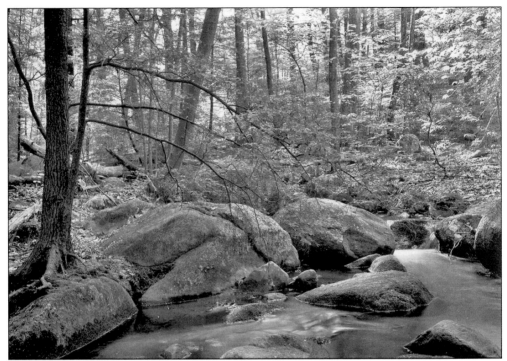

This image, captured by Cynthia Mahan, is one of the thousands of small streams that can be found in the Shenandoah National Park. The larger streams are inhabited by wild trout and stocked by local fisheries. A large number of fishermen come to Warren County to enjoy the beauty and excitement of fishing in our streams.

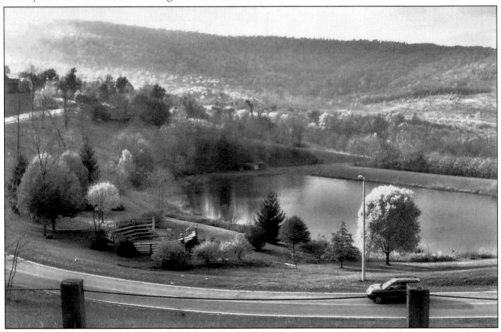

This view shows the North Virginia 4-H Center and its Lake Culpeper. Campers are taught canoeing, fishing, and the rudiments of marine biology at this site.

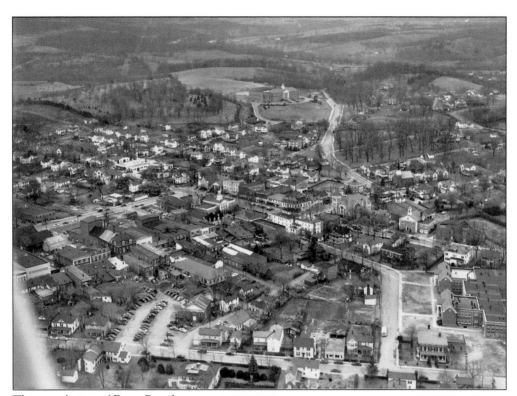

This aerial view of Front Royal, c. 1952, features E. Wilson Elementary School on Crescent Street in the lower right foreground. Warren County High School dominates the top of the hill south of the town, in the upper right center.

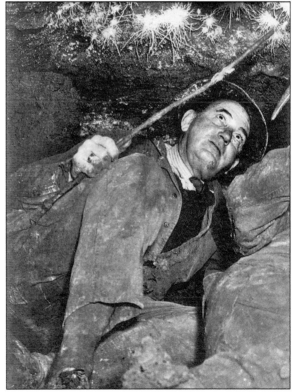

This photograph shows Skyline Caverns being explored by its founder, Dr. Walter S. Amos. These caverns were opened to the public on April 13, 1939. They were forced to close in May 1942 because of World War II rationing, but they reopened in April 1946 and have since remained a tourist attraction in Warren County. The caverns are located one mile south of Front Royal on Route 340. (Courtesy Skyline Caverns.)

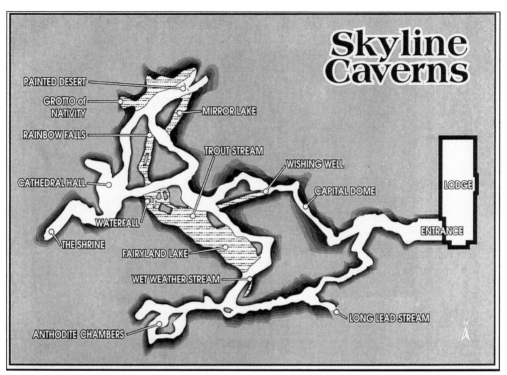

The map labels read:

PAINTED DESERT
GROTTO of NATIVITY
RAINBOW FALLS
MIRROR LAKE
TROUT STREAM
WISHING WELL
CATHEDRAL HALL
CAPITAL DOME
LODGE
WATERFALL
THE SHRINE
FAIRYLAND LAKE
ENTRANCE
WET WEATHER STREAM
ANTHODITE CHAMBERS
LONG LEAD STREAM

Skyline Caverns

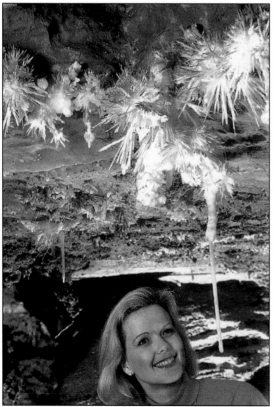

This map of Skyline Caverns highlights the deepest caverns in Virginia, extending 260 feet below the surface. The caverns feature three running streams, two seepage pools, and a 37-foot waterfall. In the 1960s the Department of Game and Inland Fisheries introduced fish into the network of streams flowing through the caverns. The cavern tour is 1.8 miles long and is restricted to the first level only. (Courtesy Skyline Caverns.)

This photograph features a scientific formation, discovered, in the caverns, by Dr. Amos. The scientific name given to these formations is anthrodites, which comes from anthros, meaning "flower like," and dites, meaning "clusters." Anthrodites are rare and, at the time of their discovery, were found only in the Skyline Caverns. Scientists estimate that it takes 7,000 years to form one linear inch of anthrodite. (Courtesy of Skyline Caverns.)

Two

AT PLAY

As soon as the area was settled, people began to look for diversions. One can only work for so long without a family feast of some sort. So intent was LeHew Town (now Front Royal) in the 18th century on spending leisure time in extreme diversion that the place was referred to as "Hell Town." Life was hard, and people played hard. As the area continued to develop economically, people tried to shed the old reputation, and picnics became the new passion. Men hunted for fun and to increase the family larder. Horse sales became events of social importance as did annual jousting festivals where men showed off their horsemanship. As is still the case, people often just turned to taking a meal on the grass. Family reunions abound to this day. In many ways Front Royal and the surrounding Warren County are merely a reflection of Southern ways.

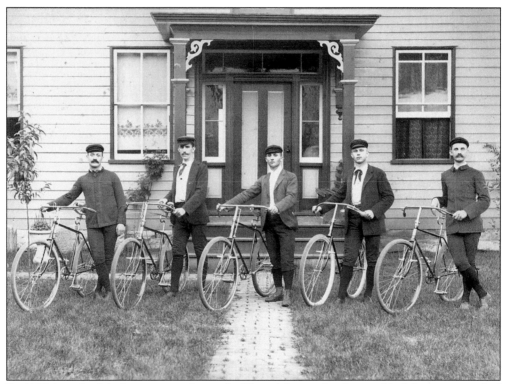

By 1885, bicycle clubs became popular in the United States. Sundays and holidays were marked by crowds of bicycle enthusiasts touring the towns. The men wore small caps, Norfolk jackets, and knickers. The Front Royal Club toured so far as Winchester, where they showed off their skills at the Ft. Loudon Seminary to the delight of the students. This group is posed in front of Belle Boyd Cottage, which still has its small Victorian porch and balcony used by Belle Boyd for a lookout.

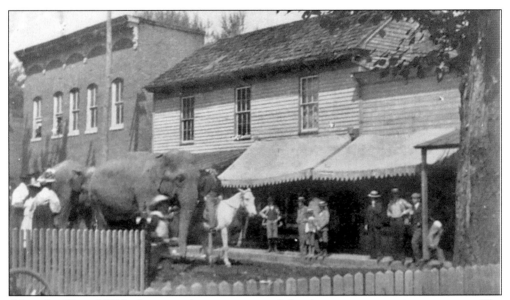

After the War of 1812, the circus became a part of the American entertainment scene. The shows traveled from town to town and pitched tents in village parks. The John Robinson Circus came out of Peru, Indiana. It was basically a Vaudeville show, which featured exotic animals. This picture was taken on Main Street, *c.* 1900. When the circus came to town, business came to a halt so that everyone could enjoy the show.

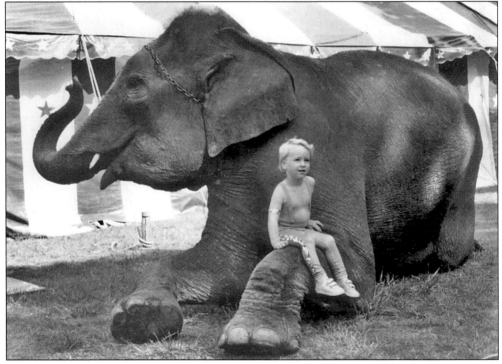

The circus continued to draw a tremendous audience in Front Royal. This more recent photograph, courtesy of the *Warren Sentinel*, of Greg Earl and his pet, Lisa the Elephant, is not dated but appears to be from the late 20th century.

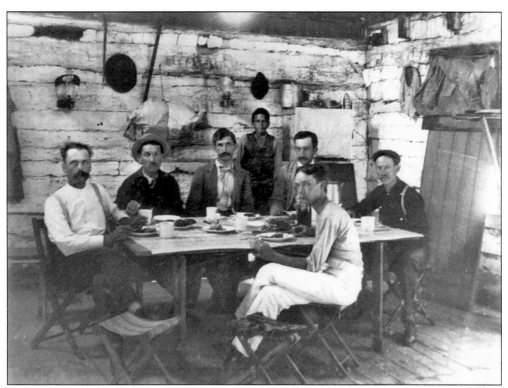

This photograph, c. 1900, features a camping party, with Mr. W.J. Kendrick on the right side of the table and, immediately to his right, Mr. J.B. Harsberger. Camping in the area is still popular. Modern camping areas include the KOA, Gooney Creek, Elizabeth Furnace, Low Water Bridge, North Fork Resort, Skyline Resorts, Shenandoah National Park, and Poe's South Fork Campground. Our largest camping area consists of 160 acres.

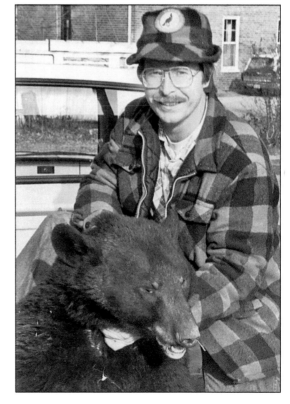

Over 50 black bears and 1,600 deer are killed in the county annually. This photograph features Colin Clem with a black bear.

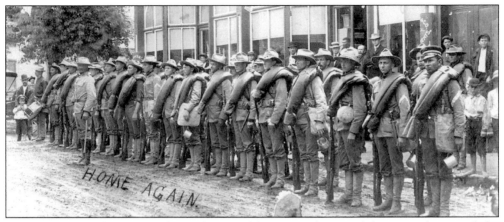

This photograph displays a welcome home celebration in honor of the men who joined the Jamestown Exposition of 1907, which lasted from April 26 to November 30. It was taken on Main Street in front of the Warren Paint and Supply. The men are wearing the official dress of the U.S. Army, the Philippine Uniform. Only two men, Charles Hall Trout and E.C. "Doc" Smith, the last two on the far right, are identified.

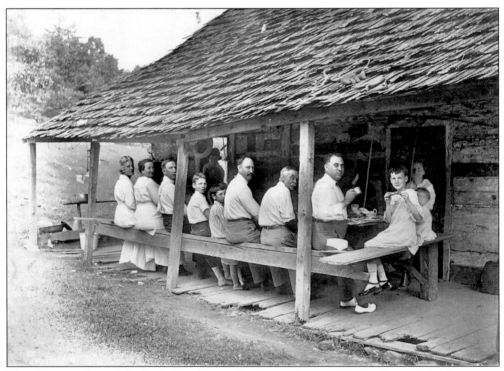

This photograph is of the Leslie Fox-Keyser family picnic, sometime in the early 20th century. Picnics and family reunions like this one are still popular with the people of Front Royal. Leslie Fox-Keyser was an educator and a major force in the Warren-Rappahannock County school systems.

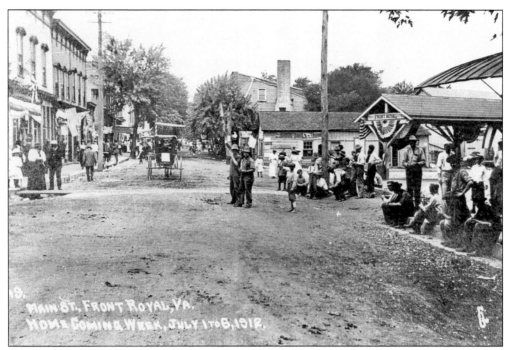

This view of Main Street during Homecoming Week, July 1–6, 1912, illustrates buildings decorated with bunting and locals waiting to witness the parade.

This photograph was taken at the Harnsbarger birthday party at the family home on Crescent Street in 1915. Refreshments included banana ice cream and orange sherbet.

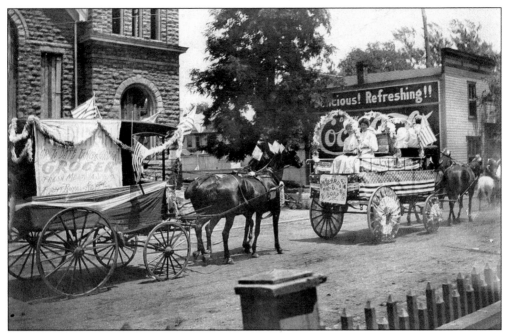

This postcard features a turn-of-the-century parade in front of the Methodist church and the Allen Building.

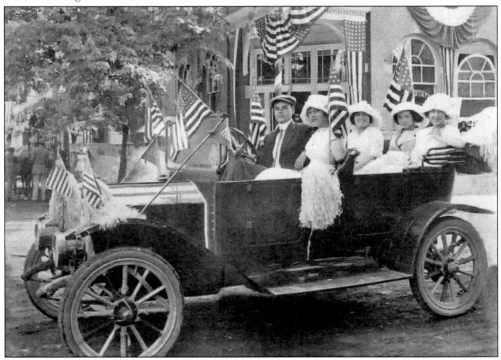

In 1919, Front Royal celebrated the return of the World War I troops with a patriotic parade. The only identified passenger is Mrs. Gladys R. Higgins, who is seated in the middle of the back seat. This photograph was taken on Main Street, in front of the Afton Inn Hotel and the Citizens National Bank, at the corner of Main and Crescent Streets.

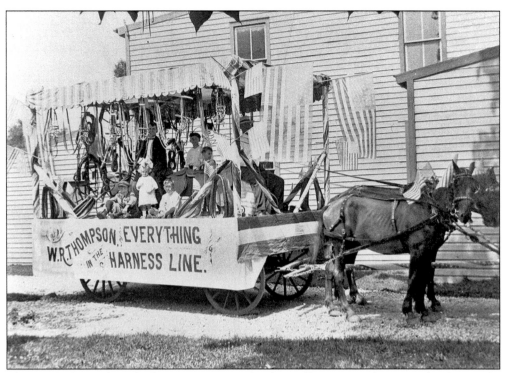

The family featured in the homecoming parade, the William Rust Thompson family, are the relatives of Carl Thompson, who owned Ramsey's hardware, the Triangle, and the Thompson home, which has been donated to the Warren Heritage Society. The family's harness shop was located at 111 Main Street.

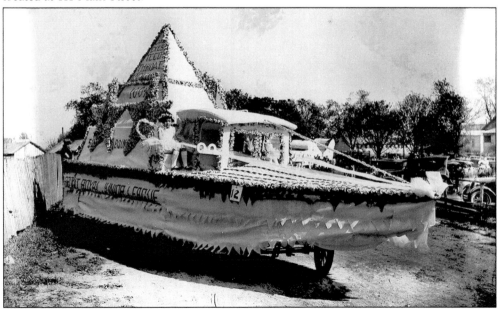

The Junior League, founded in 1901 in New York City, quickly spread throughout the country with its emphasis on social, medical, and educational issues related to women. The league often marched for female suffrage. This float appeared in a 1927 parade in Front Royal.

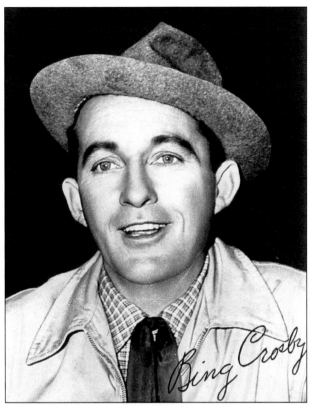

Bing Crosby

On April 1, 1950, Front Royal celebrated Bing Crosby Day. The events included a mammoth parade, the dedication of the Bing Crosby Stadium, and the world premier of Crosby's latest movie, *Riding High*. This event came about through Crosby's interest in Front Royal and his generous donations, which allowed for the construction of the town's stadium.

Beauty contests have long been a part of the Front Royal and Warren County social scene. This picture celebrates the crowning of Miss Warren County, Margaret Dewitt, in 1951. She is joined on the left by Ed Stokes and on the right by Sue Carper and Barbara Johnson. The photo was taken by Lewis E. Allen.

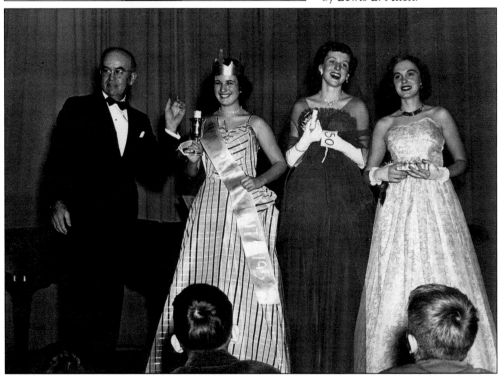

Red Socks Review was a fund-raising event that benefited the Warren Memorial Hospital. The review was sponsored by the Hospital Auxiliary and the Lion's Club. Reviews were conducted between 1962 and 1981. The people in the photograph, from left to right, are Janet Leadman, Betty Ruth Whitenack, Kay Hinchey, Sandy Gott, Sylvia Reid, and Patsy Aleshire.

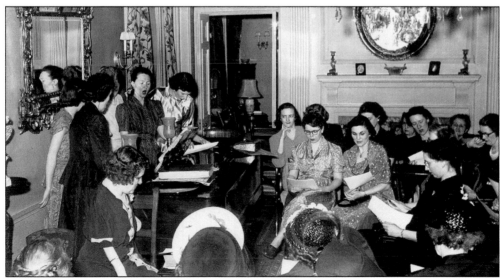

The Front Royal Music Study Club Program featured music, as well as the reading of an essay entitled, "An Evening of Music," by Laura Virginia Hale. The program was held in honor of Dr. Charles Eckardt, who taught music in Front Royal from 1850 to his death in 1879. The meeting was held in Chester House, the home of Dr. Bernard Samuels, on March 19, 1951. Laura Virginia Hale is seated beside the piano, waiting to present her paper.

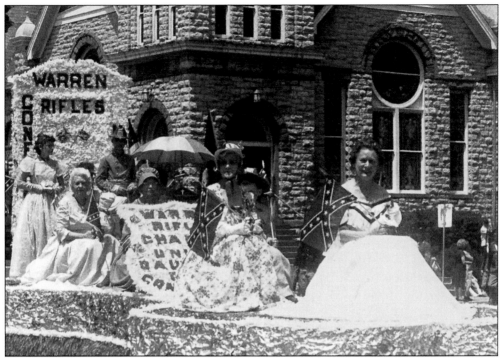

This illustrated float belonged to the Warren Rifles Chapter of the United Daughters of the Confederacy and is seen in a parade celebrating the centennial of the War between the States in May of 1962. Seated on the float, from front to back, are Lola Wood, Gretchen Bennett, and Mrs. Joseph M. Burke Sr.

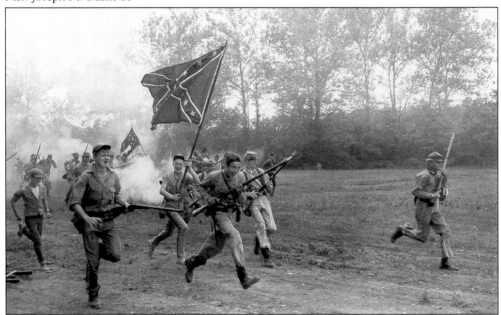

One of the earliest Civil War re-enactments was held on May 19–20, 1962. Confederates under the command of Gen. Stonewall Jackson are seen charging on Front Royal in this photograph taken by Floyd White.

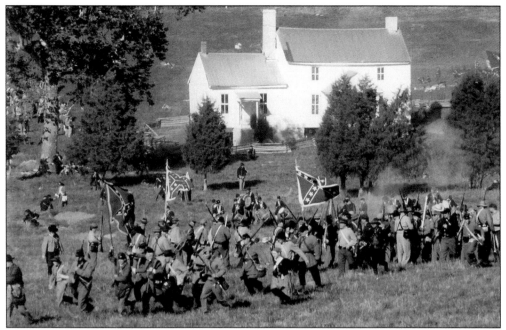

Re-enactments of the Battle of Cedar Creek have recently become popular. This photo was taken at a re-enactment in 2003 by Katie P. Morgan.

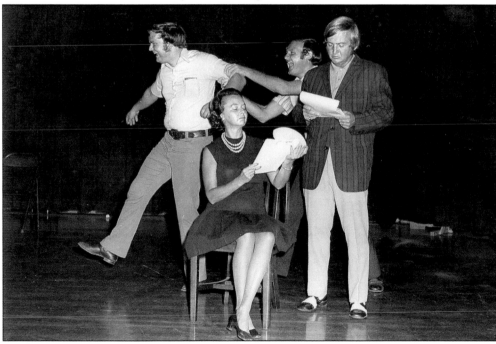

The Warren Heritage Society began its annual Festival of Leaves in 1971. This photograph was taken at the 1972 festival. The play was listed as a historical drama in the program and was entitled "A Time of Beginning." The location was the Warren County High School. Jean Derflinger Williams is seen seated and standing, from left to right, are Glenn Rose, Beverly Cameron, and Larry LeHew.

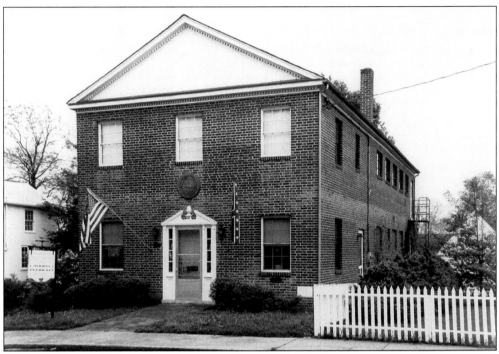

In 1954, Dr. Bernard Samuels donated a lot on Chester Street to be used for a memorial building. Fund-raising began immediately and the groundbreaking took place that same year. By 1955, construction was underway. The museum was dedicated in 1959, with appropriate ceremonies. The Honorable Strom Thurmond, the late South Carolina senator, was guest speaker. The Warren Rifles Confederate Memorial Museum is located at 95 Chester Street.

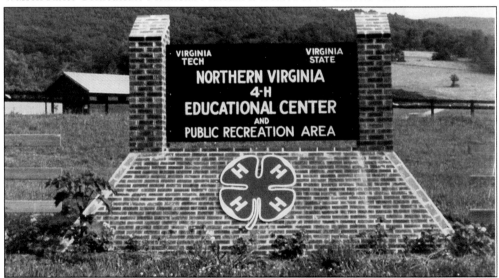

The Northern Virginia 4-H Center was built in 1976, just four miles from Front Royal, on 229 acres on Route 522. The first camping session was held in 1981, when some 270 4-H members visited the new facility. In 1982 the facilities were expanded to include a pool, volleyball, basketball, tennis courts, softball and soccer fields, an archery range, and picnic shelters. The center was so popular that, in 1986, the facilities were expanded.

Three

AT WAR

The people of Front Royal have always been ready to defend their Valley homes. During the American Revolution, the southern half of what was later to become Warren County was located in Shenandoah County. Many of the men of Front Royal joined von Muhlenberg's company. When the Commonwealth of Virginia seceded from the Union in 1861, the men of Front Royal rushed to join the Confederate States Army in support of the South's bid for independence. Close to the war front, our town suffered much at the hands of federal troops. The first occupation came on March 27, 1862, with the arrival of federal cavalry. The destruction of private property in Front Royal began immediately. By the end of hostilities and following the burning of the Valley, the people of Front Royal and Warren County faced dire living conditions and starvation.

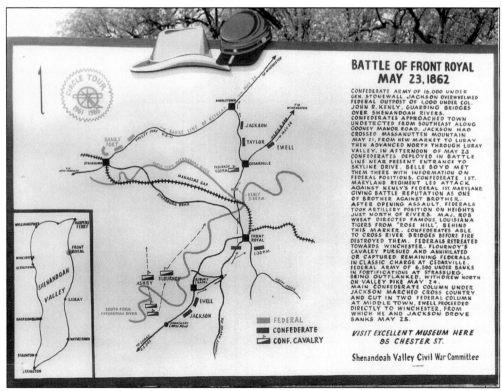

The Battle of Front Royal occurred on May 23, 1862. Stonewall Jackson's men deployed near the present location of the Church of Jesus Christ of Latter Day Saints on the Browntown Road. The retreating Yankees set fire to the bridges, but the Confederates were able to pursue them to the north and save the bridges. The battle was so successful that Stonewall was able to follow the Yankee Army and overturn the occupation of Winchester on May 25, 1862.

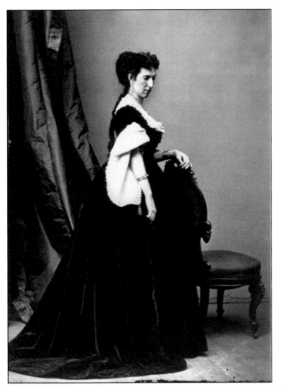

Belle Boyd came to Front Royal from Martinsburg, seeking protection. Martinsburg was closer to the war front and under almost constant federal occupation. The information she gathered here was crucial to the victory enjoyed by Jackson at the Battle of Front Royal. During the battle she had additional information to give Stonewall and crossed the battlefield, where she was knocked down by artillery fire and took several bullets in her dress. This photograph is provided by Matthew Brady.

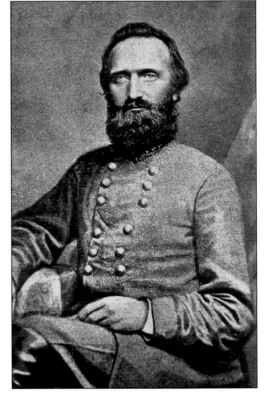

Stonewall Jackson was born in 1824 in Clarksburg. When Virginia seceded from the Union, he offered his services to his state. He gained the nickname "Stonewall" at the first Battle of Manassas. He died a victim of friendly fire in 1863. Jackson has often been compared to Napoleon, and Robert E. Lee said of Stonewall, "His spirit lives and will inspire." He continues to inspire people in Front Royal and throughout the Valley of Virginia.

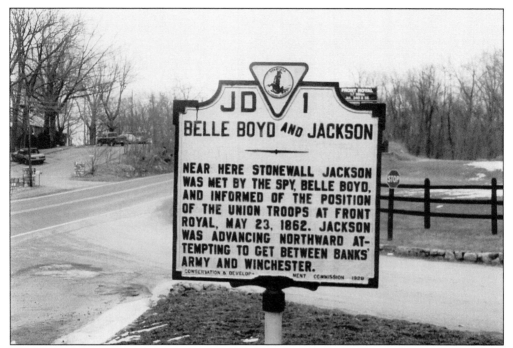

This sign marks the area where Stonewall Jackson and Belle Boyd met during the Battle of Front Royal. It is located on U.S. Route 340, near the Skyline Caverns. Front Royal is situated on the Civil War Trail, and signs identifying historical locations are everywhere. Information about the trail may be obtained at the Visitors Center on Main Street.

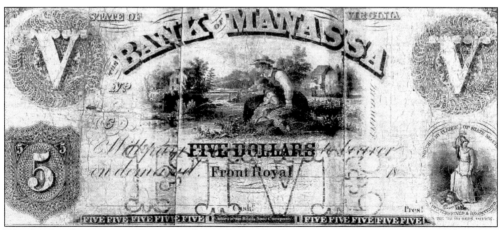

The first bank to open in Front Royal was the Bank of Manassa. The State of Virginia chartered the bank in the 1852–1853 session. Col. Edward B. Jacobs, the bank's president, organized it in 1858. This $5 bank note was issued by the Bank of Manassa early in the war. The Bank of Manassa was one of the first commercial victims of the war and ceased operations in May of 1862. (Courtesy of Laura Denny.)

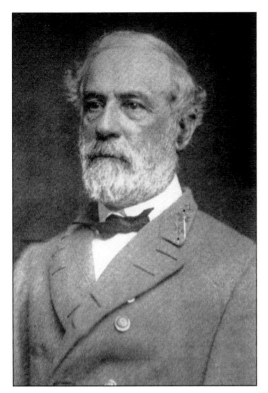

Robert E. Lee was born in 1807 and graduated from West Point in 1829. He visited Front Royal on July 22, 1863, on his return from the Battle of Gettysburg. He spent the day at Bel Air, and his comments were recorded by Lucy Buck in her diary. Lucy proudly called him the "Father of our State." During the visit, Lucy and her sister, Nellie, played patriotic Southern songs on the piano, the most notable of which was the "War Chant of Defiance." Lee is often fondly referred to as "Uncle Robert," "Marse Robert," or the "Good General."

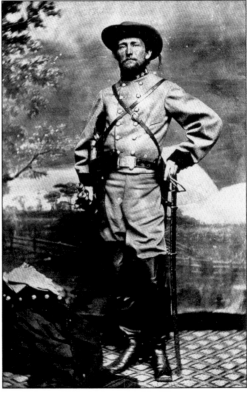

John Singleton Mosby (1833–1916) joined the Confederate States Army upon Virginia's secession from the Union. His area of operation in the Loudoun Valley of Virginia became known as Mosby's Confederacy. His connection to Front Royal comes from an aborted raid on a Yankee wagon train. Six of his men were executed without trial, and Mosby swore to avenge their deaths. Robert E. Lee cited Mosby for meritorious service more than any other officer in the Confederate States Army.

The Battle of Cedar Creek, fought on October 19, 1864, extended from Warren to Frederick to Shenandoah County. The Confederates, under Gen. Jubal Early, numbered about 20,000 troops. In the early morning hours the Confederates surprised 30,000 federal soldiers on Cedar Creek. The people of Front Royal stood on the hills overlooking the battle area and watched the action throughout the day.

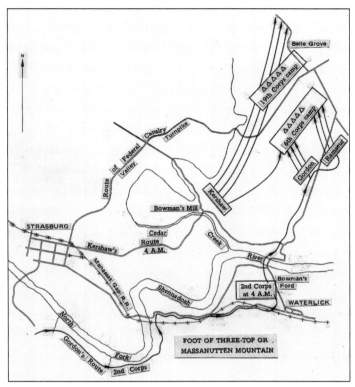

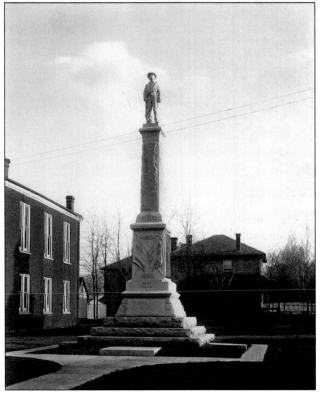

This major Confederate monument is located at the courthouse on the southeast corner of Main Street and South Royal Avenue, which was known as Manor Grade, since it was the road leading to the Gooney Manor detailed in Lord Fairfax's many land grants during the war. The monument was dedicated on July 4, 1911, with Mr. Irving A. Buck as chairman of the monument committee and Col. S.R. Millar as the master of ceremonies.

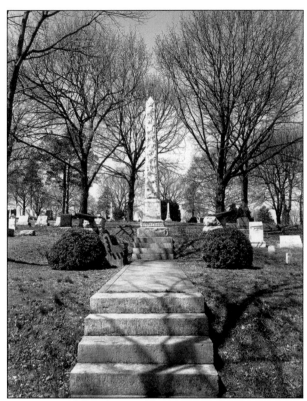

This photograph features the Mosby Monument at Prospect Hill Cemetery. It was "erected 1899 by the survivors of Mosby's command in memory of the seven comrades executed while prisoners of war near this spot September 23rd 1864." Money to finance the monument was raised by dividing the walnut tree where Overby and Love were executed into sections and selling the blocks of wood. September 23, 1864, is known as "The Dark Day of 1864." This photograph was taken by Lewis E. Allen.

This tribute to the Confederate dead is located in the Soldiers' Circle at Prospect Hill Cemetery. The photograph was taken by Floyd White.

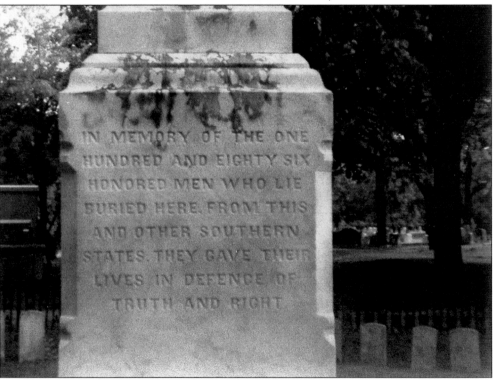

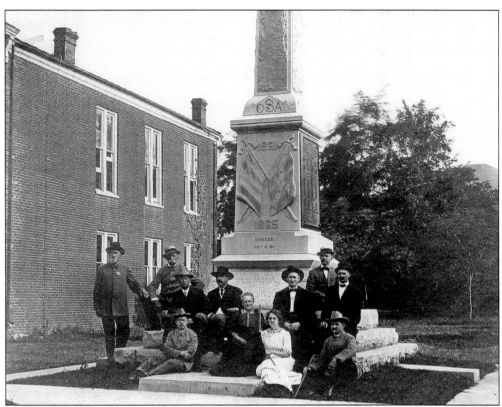

This photograph, taken by A.N. Carroll, displays Confederate veterans at the courthouse. In the image are, from left to right, (front row) Irving Ashby Buck, Mrs. I.A. Buck, Miss Margaret Grayson, and William C. Grayson; (middle row) Samuel A. Allen, Joseph Stickley, Jack Lake, and unidentified; (back row) William A. Compton.

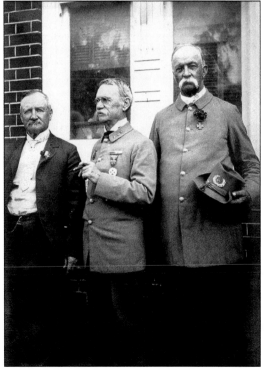

This photograph, taken before 1923, features the CSA veteran group. From left to right are Dick Bayly, Irving Buck, and William Robinson. As long as they survived, our Confederate veterans were the central attraction for every festivity in the county.

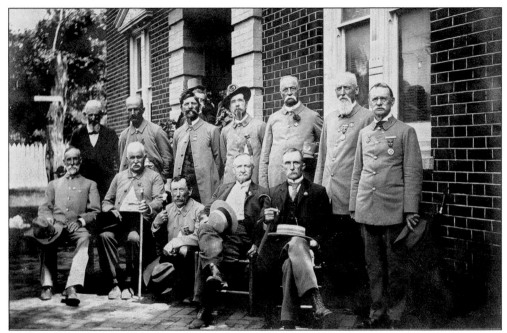

Here is the CSA veterans group; from left to right are (seated) Capt. Wesley LeHew, Cameron, Charles Buck, Dick Bayly, and Dick Blakemore; (standing) Johnson Pomeroy, Fred Keeper, Samuel Eccleston Macatee, C. "Bud" Grimes, William Robinson, Capt. Samuel Jefferson Simpson, and Irvin A. Buck.

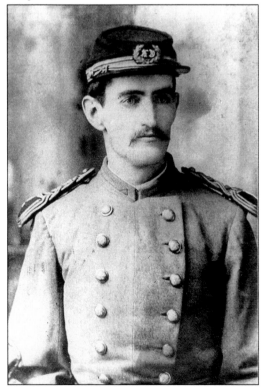

William Thomas Overby, a Mosby Ranger from Georgia, was captured during the aborted raid on September 23, 1864. He was prepared for execution and given an opportunity to save his life if he would disclose the location of Mosby's headquarters. Overby declared, "John Singleton Mosby will have ten of you for every one of us." With that, the executioners cracked the whip and the two men were left to hang by their necks. Overby's body was returned to Georgia for a hero's burial in 1997. This photograph was taken by Thomas Spencer.

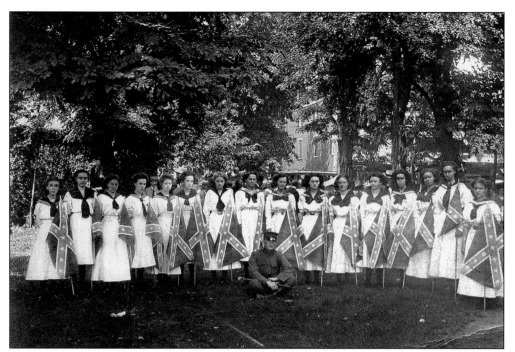

This photograph of the Junior Memorial Drill was probably taken after the World War I homecoming parade. The custom of marching around the Soldiers' Circle at Prospect Hill Cemetery was continued for many years on May 23. After this particular event the United Daughters of the Confederacy fed those who took part in the memorial.

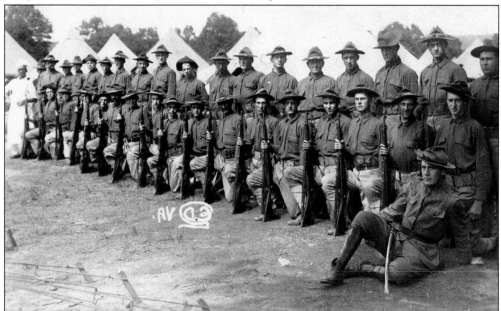

The National Guard is the oldest component of the military in the United States, dating back to the Colonial Indian Wars. In 1792 all males between the ages of 18 and 45 were required to join the militia. The National Guard distinguished itself in the Spanish-American War and experienced great modernization between 1910 and 1916, when this photo was taken.

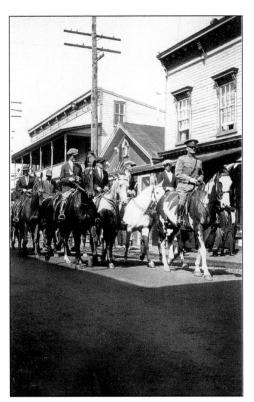

War hostilities ended on November 11, 1918. This photograph marks the return of Front Royal's soldiers for a homecoming, which lasted from July 21 through July 23, 1919. The veterans enjoyed happy festivities, the least of which was a parade down Main Street. The brick building in the center was the first location of the Bank of Warren. Today this building houses the law firm of John G. Cadden.

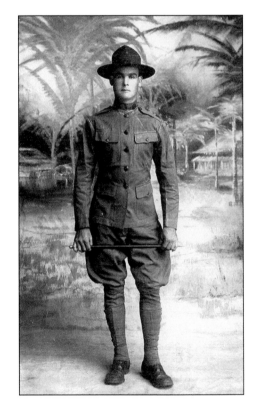

This photograph features Pvt. M. Steward, World War I soldier and uncle of local photographer J.S. Wetzel. The photograph is from the *Warren Sentinel* collection.

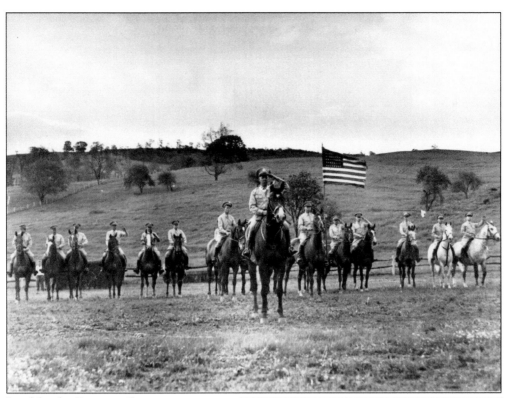

Land for the Remount Station was purchased by the United States in 1910. The place soon became famous for the Remount Cavalry. Here is a formation of the Horse Cavalry during World War II. By this time, the use of cavalry was in sharp decline, in terms of importance to modern warfare, and the Remount shifted its training from horse breeding to the training of dogs for warfare.

Gen. "Blackjack" Pershing's horses, Jeff and Kidron, are seen c. 1936 at Remount Depot, where they died in 1942. Remount was known for its horse breeding accomplishments and later became a training ground for the dogs used in World War II.

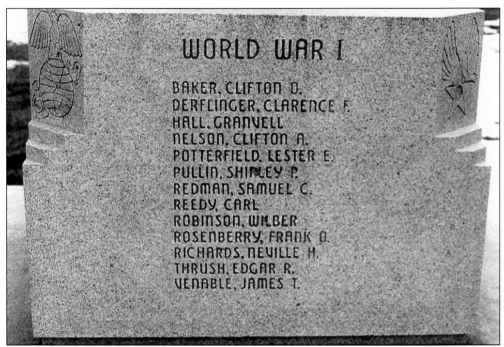

WORLD WAR I

BAKER, CLIFTON D.
DERFLINGER, CLARENCE F.
HALL, GRANVELL
NELSON, CLIFTON A.
POTTERFIELD, LESTER E.
PULLIN, SHIRLEY P.
REDMAN, SAMUEL C.
REEDY, CARL
ROBINSON, WILBER
ROSENBERRY, FRANK D.
RICHARDS, NEVILLE H.
THRUSH, EDGAR R.
VENABLE, JAMES T.

U.S. participation in World War I began in 1917 and ended in 1919. The men of Front Royal who volunteered to serve are memorialized in a monument located on the courthouse grounds.

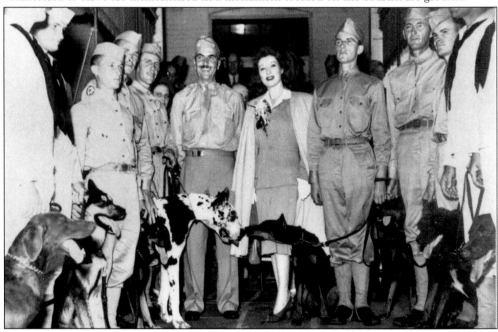

U.S. participation in World War II was far more intense than that of World War I. People saved anything and everything to aid the war effort. Bond sales were a regular event between 1941 and 1945. This undated photograph celebrates the arrival of Greer Garson in Front Royal to promote the sale of war bonds. The man on her right is Col. T.B. Apgar, who taught in Warren County High Schools after the war.

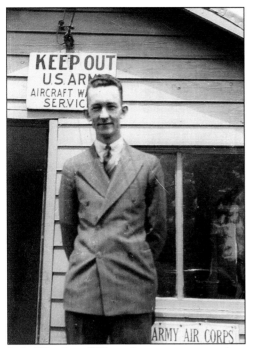
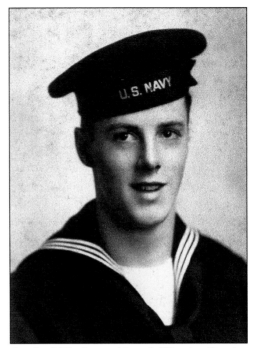

Left: Woodrow Wilson Pomeroy was an observer for the U.S. Army Aircraft Warning Service (Civil Defense). The observation station was located on Grand Avenue near Huffman's Barn. *Right:* The man photographed is Chester Duke, a seaman for the U.S. Navy, in uniform during World War II.

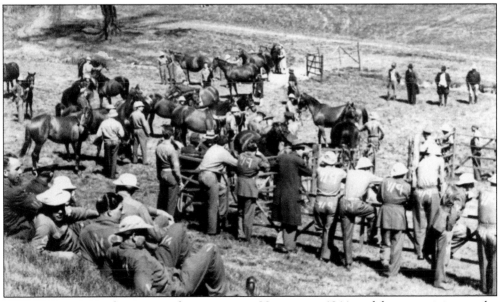

German prisoners of war started coming into Virginia in 1944 and began arriving at the Remount Depot in April 1945. Eventually, they numbered over 400 men. The POWs were employed under contract to harvest apples and other crops needed on the Pacific war front and were paid between 37¢ and 40¢ an hour. To this day an occasional former German POW visits Front Royal to rekindle old friendships

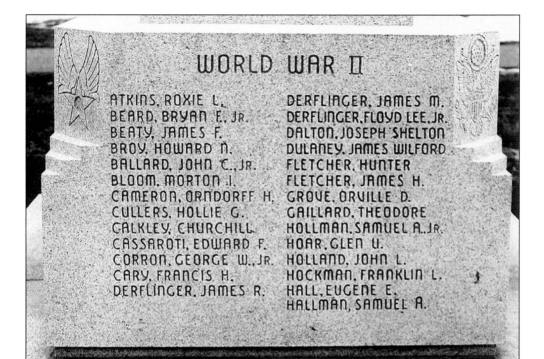

WORLD WAR II

ATKINS, ROXIE L.
BEARD, BRYAN E., JR.
BEATY, JAMES F.
BROY, HOWARD N.
BALLARD, JOHN C., JR.
BLOOM, MORTON I.
CAMERON, ORNDORFF H.
CULLERS, HOLLIE G.
CALKLEY, CHURCHILL
CASSAROTI, EDWARD F.
CORRON, GEORGE W., JR.
CARY, FRANCIS H.
DERFLINGER, JAMES R.

DERFLINGER, JAMES M.
DERFLINGER, FLOYD LEE, JR.
DALTON, JOSEPH SHELTON
DULANEY, JAMES WILFORD
FLETCHER, HUNTER
FLETCHER, JAMES H.
GROVE, ORVILLE D.
GAILLARD, THEODORE
HOLLMAN, SAMUEL A., JR.
HOAR, GLEN U.
HOLLAND, JOHN L.
HOCKMAN, FRANKLIN L.
HALL, EUGENE E.
HALLMAN, SAMUEL A.

These photographs feature a World War II monument. The war began after Pearl Harbor, in December of 1941. The men memorialized here gave their lives in the defense of freedom.

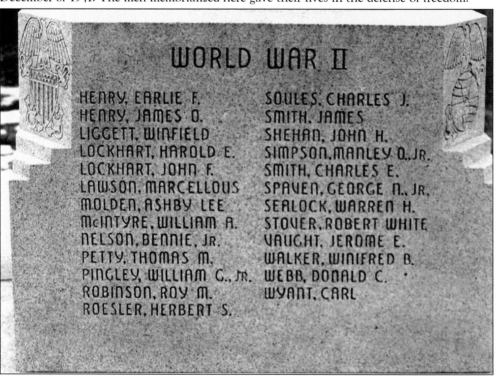

WORLD WAR II

HENRY, EARLIE F.
HENRY, JAMES O.
LIGGETT, WINFIELD
LOCKHART, HAROLD E.
LOCKHART, JOHN F.
LAWSON, MARCELLOUS
MOLDEN, ASHBY LEE
McINTYRE, WILLIAM A.
NELSON, BENNIE, JR.
PETTY, THOMAS M.
PINGLEY, WILLIAM C., JR.
ROBINSON, ROY M.
ROESLER, HERBERT S.

SOULES, CHARLES J.
SMITH, JAMES
SHEHAN, JOHN H.
SIMPSON, MANLEY O., JR.
SMITH, CHARLES E.
SPAVEN, GEORGE N., JR.
SEALOCK, WARREN H.
STOVER, ROBERT WHITE
VAUGHT, JEROME E.
WALKER, WINIFRED B.
WEBB, DONALD C.
WYANT, CARL

John Affleck, U.S. Army Air Corp staff
sergeant, served in World War II as a
gunner on a B-17 Bomber, which was shot
down over Hamburg, Germany, on New
Year's Eve of 1944. He spent four months
in three different German POW camps.
The Laura Virginia Hale Archives is in
possession of audio tapes made by Affleck
describing his experiences as a POW.
(Courtesy of Beth Waller.)

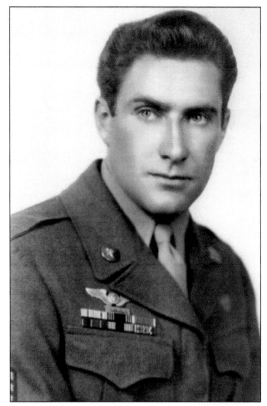

Affleck's airplane, a B-17 Bomber named
"Faithful Forever," flew missions over
Germany from runways in the United
Kingdom. The bomber was destroyed as
described above over Hamburg in 1944.
(Courtesy of Beth Waller.)

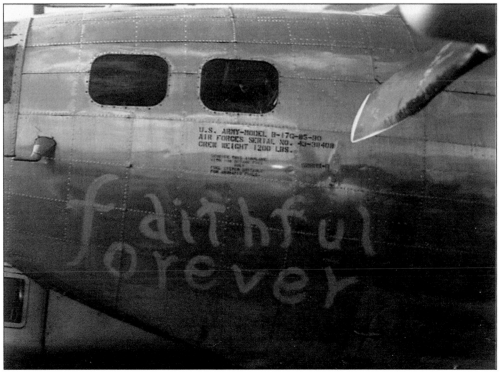

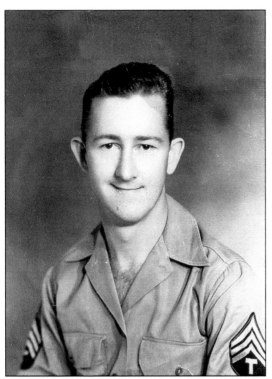

Sgt. Edwin L. Pomeroy served the U.S. Army in the Philippines during World War II. Years later he worked as the Veteran Administration Representative in Front Royal for Warren County and several surrounding counties.

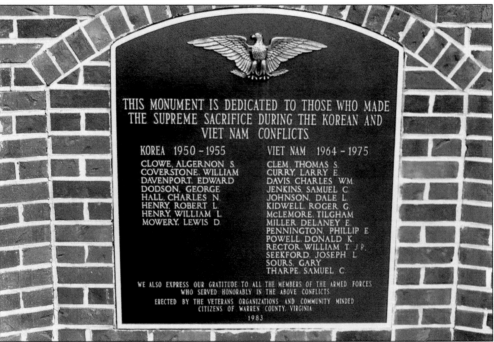

THIS MONUMENT IS DEDICATED TO THOSE WHO MADE THE SUPREME SACRIFICE DURING THE KOREAN AND VIET NAM CONFLICTS

KOREA 1950 - 1955

CLOWE, ALGERNON S.
COVERSTONE, WILLIAM
DAVENPORT, EDWARD
DODSON, GEORGE
HALL, CHARLES N.
HENRY, ROBERT L.
HENRY, WILLIAM L.
MOWERY, LEWIS D.

VIET NAM 1964 - 1975

CLEM, THOMAS S.
CURRY, LARRY E.
DAVIS, CHARLES WM.
JENKINS, SAMUEL C.
JOHNSON, DALE L.
KIDWELL, ROGER G.
MCLEMORE, TILGHAM
MILLER, DELANEY E.
PENNINGTON, PHILLIP E.
POWELL, DONALD K.
RECTOR, WILLIAM T. JR.
SEEKFORD, JOSEPH L.
SOURS, GARY
THARPE, SAMUEL C.

WE ALSO EXPRESS OUR GRATITUDE TO ALL THE MEMBERS OF THE ARMED FORCES WHO SERVED HONORABLY IN THE ABOVE CONFLICTS

ERECTED BY THE VETERANS ORGANIZATIONS AND COMMUNITY MINDED CITIZENS OF WARREN COUNTY, VIRGINIA

1983

The Korea and Vietnam Monument is located on the courthouse grounds. Edwin L. Pomeroy mustered local support to build this tribute to the men who served in those wars. He approached individuals, businesses, veterans' organizations, and other civic groups to support the construction of this monument.

Four

IN CRISIS

Front Royal and surrounding Warren County have had more than their share of natural and man-made disasters. The mighty Shenandoah River runs through the county and on the outskirts of the town. Floods have been recorded in the area in 1870 at 48 feet, 1877 at 41 feet, 1889 at 36 feet, 1896 at 34 feet, 1924 at 34 feet, 1936 at 38 feet, and 1942 at 50 feet. Some of these disasters were recorded on film and lost. Often well-meaning photographers rushed to the river to take shots, and ended up with photographs showing water but no landmarks. The few photographs provided here show examples when photographers, both professional and amateur, were on the scene of a disaster.

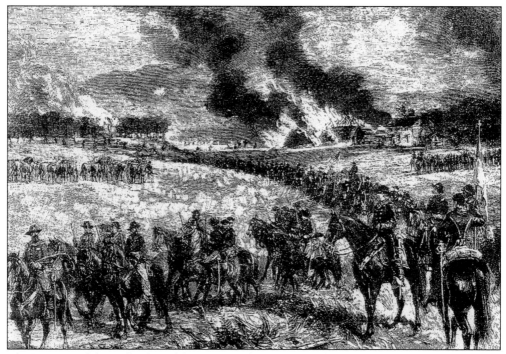

The Burning of the Valley lasted from September 26 to October 8, 1864. Over 2,000 barns and 70 mills filled with wheat and flour were burned. All livestock were driven away or slaughtered. The destruction extended south of Front Royal to include Page Valley and Shenandoah County including Fort Valley, south to Staunton. Following the fire, the people of Warren County and Front Royal faced starvation.

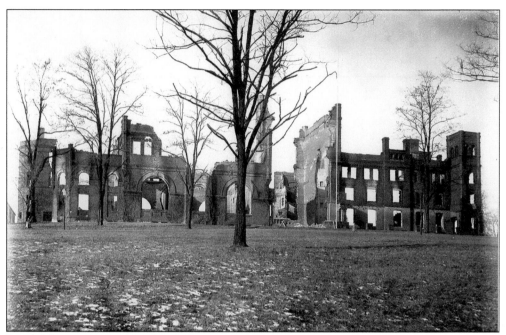

Randolph-Macon Academy burned in January of 1927, at a time when Front Royal was little prepared to handle a disaster of this magnitude. Ten students were injured, and the school suffered a financial loss of $300,000. Students and faculty were welcomed into local homes and the new building was ready for use in the fall of 1927.

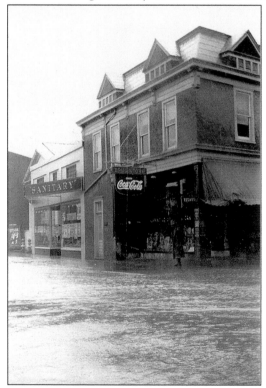

This photograph of the Flood of 1936 was captured by a member of the Wood family. During such floods, particularly in the case of 1936, Happy Creek became a river and Blue Ridge Avenue became one of its tributaries, bringing water to Main Street and the shops located there. During this and other major floods, the cadets at Randolph-Macon Academy assisted in controlling the water. (Courtesy of Jane Wood Vaughan.)

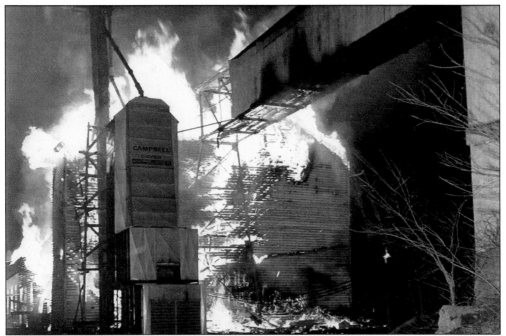

The Riverton Mills Fire on March 23, 1957, destroyed much of the mill, including a large wooden building, grain bins, and a conveyer. Only the large concrete grain elevators were left standing. The fire raged for most of the night and was visible for 20 miles. Some 38 Front Royal firefighters were involved in controlling the blaze, while the police fought to control traffic in the area.

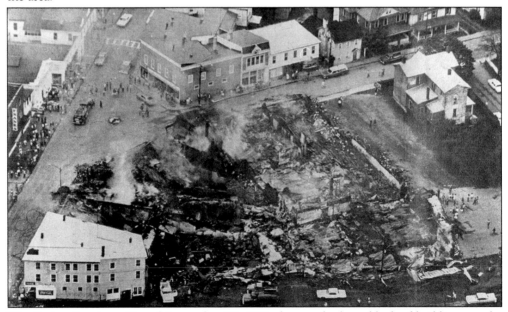

The Stokes Furniture Fire of September 20, 1969, destroyed a huge block of buildings on the corner of Chester and Main Streets. Thirty apartment-dwelling families were left homeless. Nine fire companies from the surrounding area fought the blaze. So total was the destruction that no effort was made to rebuild. Today the area is a park, dominated by a gazebo.

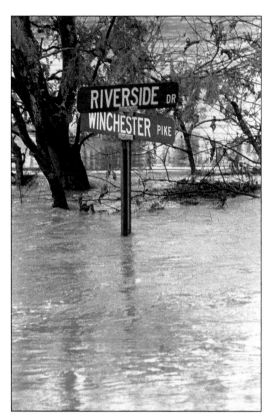

During the Flood of 1985, the Shenandoah River crested at 35.4 feet. The flood was initiated by unusually heavy rains. The two photographs presented here give an idea as to the power of the Shenandoah's waters during flooding. Riverside Drive is located in the community of Riverton.

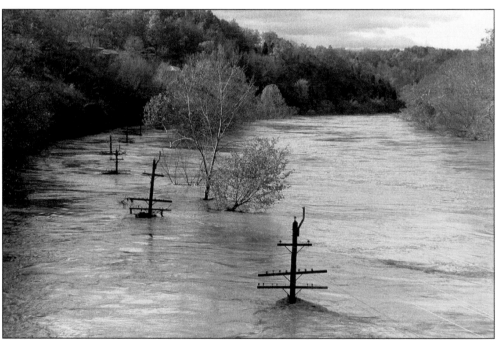

Telephone poles and the roads beside them are dramatically submerged by the Shenandoah's rising waters during the Flood of 1985.

Five

AT WORK

Front Royal has always been a business hub, with ups and downs caused by the War between the States and the normal fluctuations of the market. While the rich farms of the Valley of Virginia were the primary source of business activity, they were joined early on by the mineral mining. A pamphlet published by the chamber of commerce at the height of this boom period, c. 1920, presents Front Royal as a business hub for the Upper Valley of Virginia. A fine array of businesses centered on Main Street, and the wealth generated produced a number of stately mansions. The pamphlet boasted of 15 large and prosperous industries, which produced fruit products from local orchards and vineyards. Furthermore, huge industrial mills had replaced the small family run mills and mines of the antebellum period.

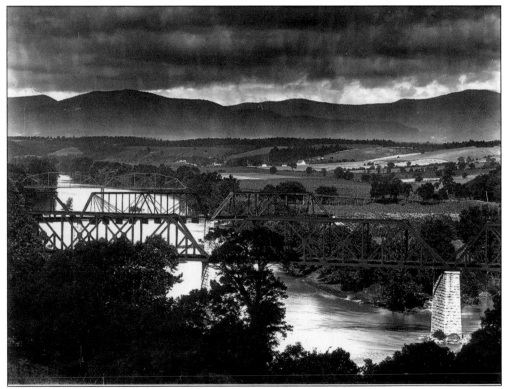

The iron bridges between Front Royal and Riverton, dedicated May 1, 1894, were the community's major method of access to Front Royal's business district. The wooden bridges were destroyed by a flood in 1862, and a ferry service was used until 1894. The iron bridges were part of the economic boom of the last decade of the 19th century. These bridges served the community until 1940, when they were replaced by modern structures. The May 1, 1894 dedication was attended by 10,000 people

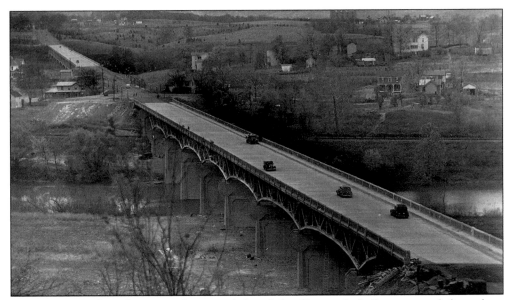

The current bridges that span the twin forks of the Shenandoah River were dedicated on November 17, 1941, by Gov. James H. Price of Virginia. The two bridges, costing a total of $1,250,000, represented the largest project ever undertaken by the Virginia State Highway Commission. The dedication was highlighted by a parade of 900 school children, led by the Randolph-Macon Academy band. Over 9,000 people came to witness the dedication ceremony. The three smoke stacks of Avtex are visible to the right.

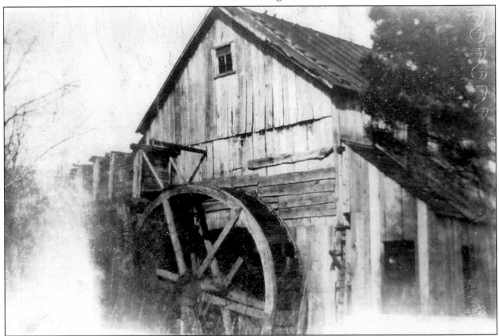

Buckton Mill was the only local grist mill to survive the burning in 1864. A free black man named Uncle Jim worked at the mill and prevented its destruction when Sheridan's men arrived to burn the building. Sheridan's men destroyed over 70 mills. This photo was taken from the Buck Papers of Nellie Brady and Dawson Becktold.

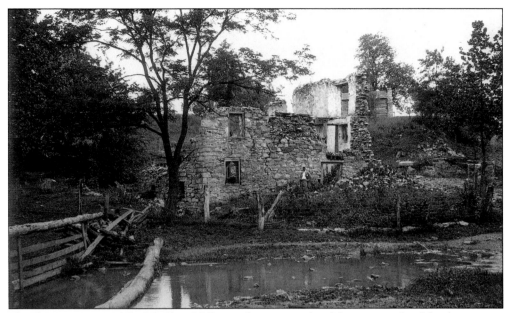

The dramatic ruins of the Mt. Zion Mill provide an example of the magnitude of the destruction of the Burning of the Valley in 1864. So impressive are the remains of the Mt. Zion Mill that the place has been the subject of multiple paintings and photographic art.

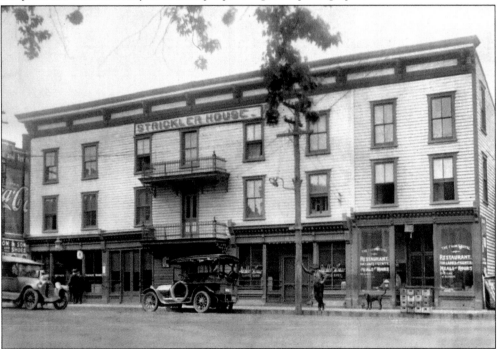

The Fishback Hotel, or Strickler House, was located where Chester Street joins Main Street. During the Civil War, Belle Boyd began her career as a Confederate spy at the hotel. The Fishback was one of the few commercial buildings to survive the war. Today the old Fishback is the home of Second Chance, a consignment clothing store. The floors above the store are occupied by a women's shelter.

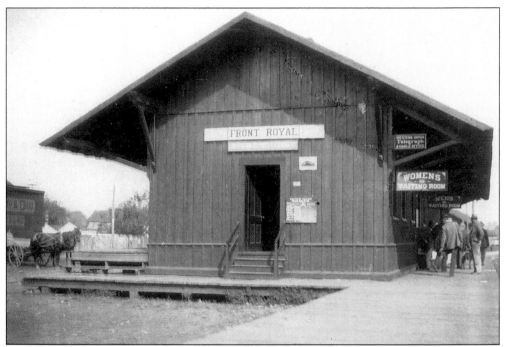

Front Royal owes its early existence to the confluence of the North and South forks of the Shenandoah River. The area's commercial importance got a big boost in 1854 when the Manassas Gap Rail Road was extended to Front Royal. During the Civil War the area's production supported the Confederacy, though the railroad line did not survive the war. This station was built c. 1870 and may be the same building now occupied by the Visitors Center.

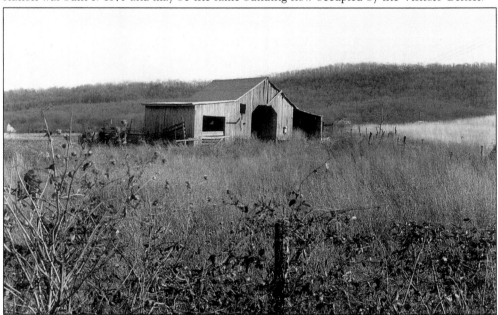

The barn at Happy Creek was constructed after the Civil War. Warren County lost all of its barns during the Burning of the Valley in 1864. This photograph was part of a *Warren Sentinel* series on barns, published from 1981 to 1984.

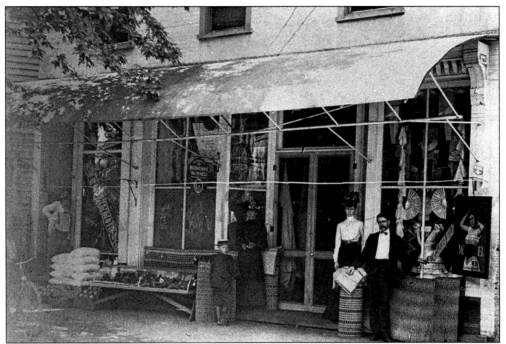

During the 1890s, Front Royal and Warren County experienced a tremendous surge in business and began its recovery from the Civil War. Compton's General Store, c. 1890, located on the corner of Chester and Main, is one of the shops that profited from these booming conditions. The building still stands on Main Street, though it later became Stokes' Furniture and is now the Main Street Pawn Shop.

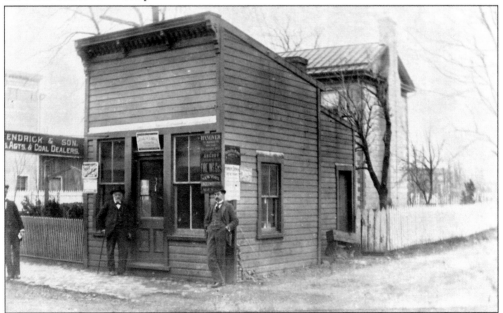

W.J. Kendrick and Son was located on Main Street, halfway between the courthouse and the Park Theater. The alley on the right no longer exists. Craig Kendrick and Company was the first to handle real estate and stocks.

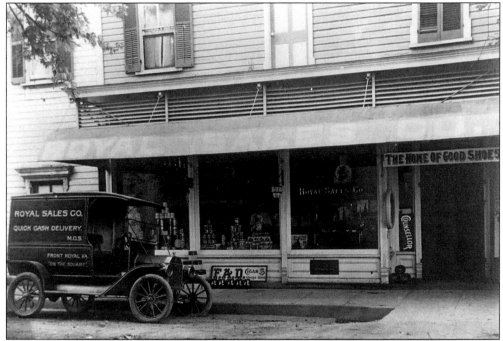

Royal Sales Company was built by the Grigg family in the 19th century. The building originally served as a general store. The delivery truck had to be one of the first motorized commercial vehicles in Front Royal. At the time this photograph was taken, in the early 20th century, Front Royal and Warren County were still in the midst of commercial boom conditions.

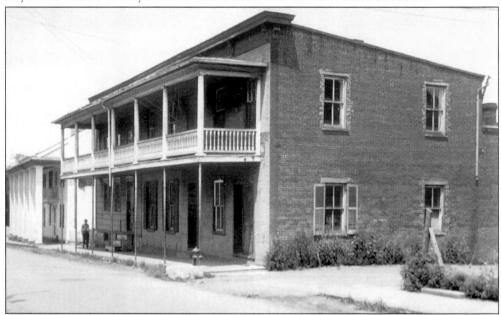

Gideon Jones, often referred to as the merchant prince of Front Royal, was appointed postmaster in 1848 and served under the United States and the Confederate States of America. He began to work in Reed's General Store at age 11 and quickly learned the business, which became the source of his wealth. Gideon Jones's store was located next to the Trout-Brown Apartments.

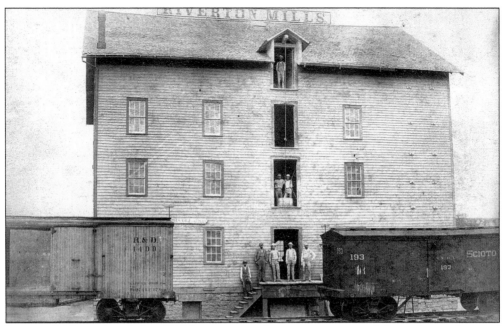

Riverton Mill was founded in 1892 by a joint stock company, as part of the real estate boom of the 1890s. It continued to produce flour until destroyed by fire in 1912.

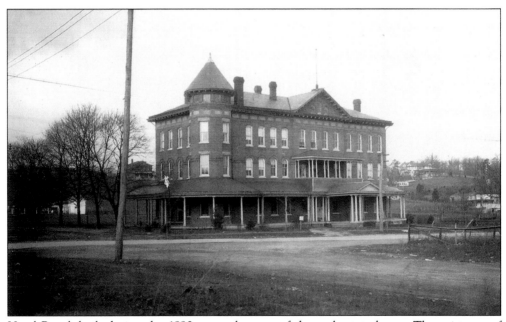

Hotel Royal, built during the 1890s, was also part of the real estate boom. The existence of such a grand hotel attests to the importance of Front Royal as a business community. The hotel later became Eastern College, which burned in 1911. Today the site is the location of the 7-11 convenience store on North Royal Street.

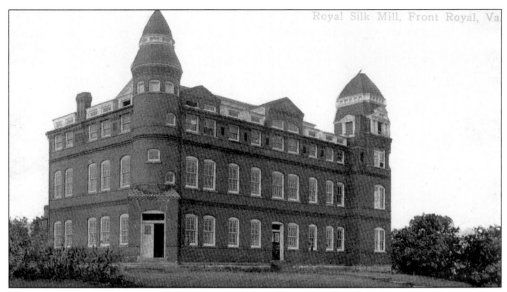

This building originally housed the Leicester Piano Company. Royal Silk Mill began operations in 1913, when a group out of Harrisonburg purchased the old Royal Tapestry Company for $7,000. At the height of its operation, the Royal Silk Mill produced two million yards of cloth and employed more than 300 people. Today the building is occupied by the Shamrock Furniture Factory.

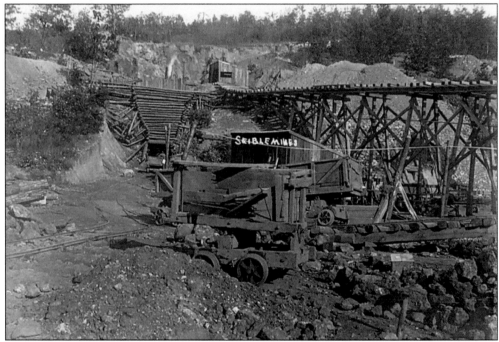

Seible Mines specialized in manganese deposits found in Happy Creek. The area of excavation was on the mountain side, just east of the town of Happy Creek. The ore was taken from the mine to a processing plant on Happy Creek Road, via a dingy line train. The mine declined early in the 20th century, and the land was eventually sold. For a short time during World War II, it was thought that manganese would be in great demand, but this need never materialized

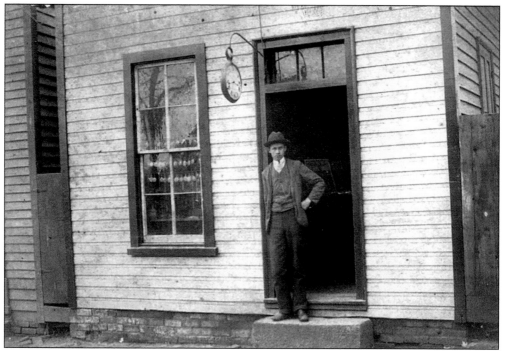

This photograph of Bowman's Jewelry Store was taken by an unknown photographer around 1902. William Welton Beaty (1872–1946), grandfather of Shirley MacLaine and Warren Beaty, is standing in the doorway.

Horse sales were common in Front Royal in a time when horses provided the majority of transportation. This sale was conducted on Main Street, in 1913, in front of the courthouse.

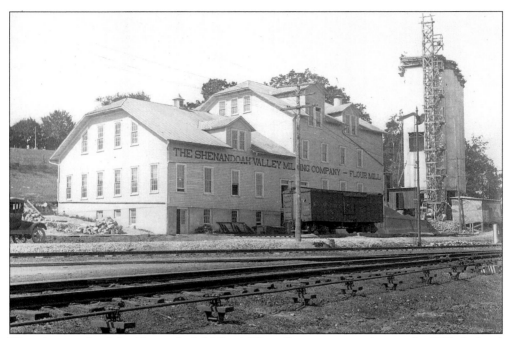

This photograph of the Shenandoah Valley Milling Company was taken in the 1920s by local photographer A.N. Carroll. This mill was a major supplier of flour in Front Royal and Warren County and produced two brands of self-rising flour. In 1919, the Shenandoah Valley Milling Company was a major part of the movement to harness the Shenandoah's waters for industrial use. By the early 20th century, however, most mills had abandoned water power for electricity.

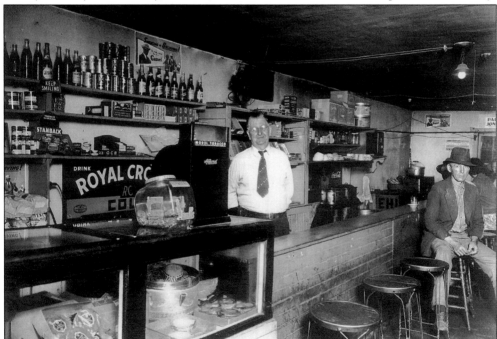

Adelsberger's Store on Main Street, which later became the Duck Inn Restaurant, is now the gallery of a local artist, Pat Windrow.

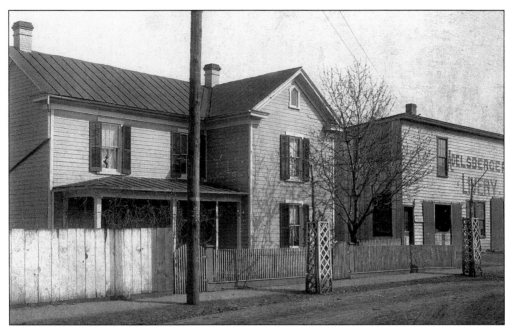

Adelsberger's House, Livery and Feed Stable stood on the southeast corner of Lee and Main Street, near the Afton Inn. Adelsberger offered rentals of fine carriages, which were often used for weddings and funerals. He did much business with summer visitors and traveling men.

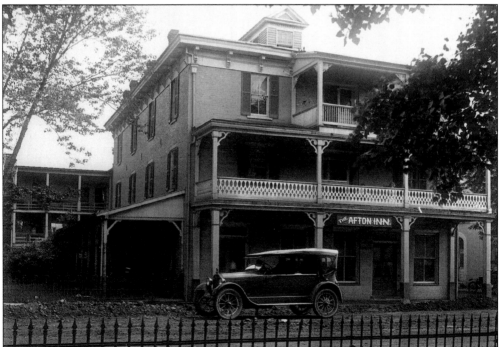

The Afton Inn, built between 1866 and 1868, was the social center of Front Royal. During peak season, the inn catered to bird hunters and bass fishermen. It boasted 42 rooms, and its front veranda was used by politicians to deliver speeches to large crowds that gathered on Main Street. Rev. J.S. Hedrick destroyed the veranda when he plunged his automobile into it.

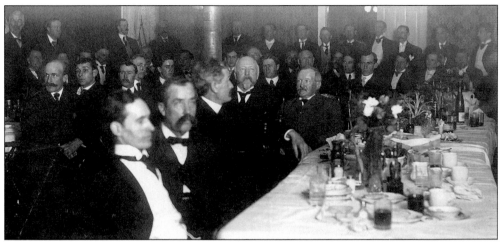

This photograph illustrates one of the many banquets celebrated at the Afton Inn. After the inn had outlived its popularity, the restaurant remained an important place to dine.

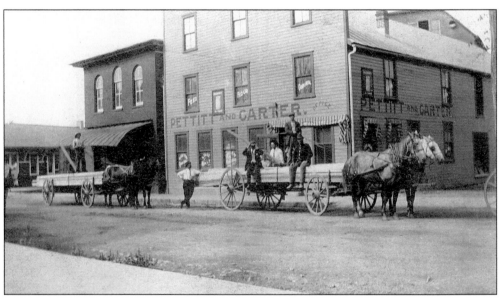

Pettit and Carter Mills was the predecessor to Procter and Biggs Mills, which still stands on Main Street. The mill was constructed for easy access to the railroad and remains close to the old railroad station, which is now the Visitors Center. At one point, the mill produced 150 barrels of feed per day.

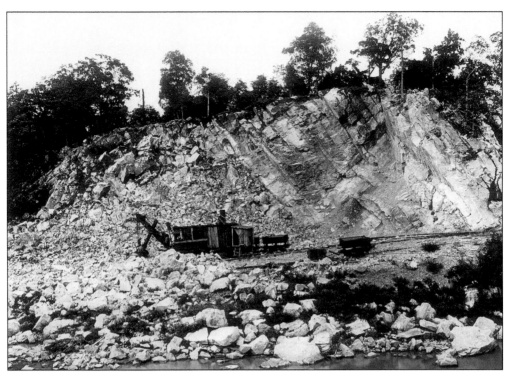

Carson and Son stone quarry, or Limeton Lime Company, founded by Samuel Carson in 1868, has manufactured lime for building, chemical, and agricultural needs. The company had the capacity to produce 100,000 tons of crushed lime and 10,000 tons of various types of lime per year.

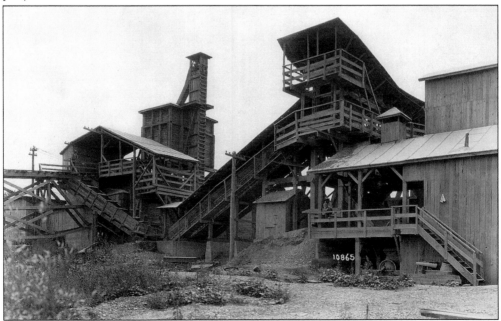

This photograph features Carson and Son buildings, where the limestone was processed from crushed stone for road-building materials and sophisticated chemical compounds.

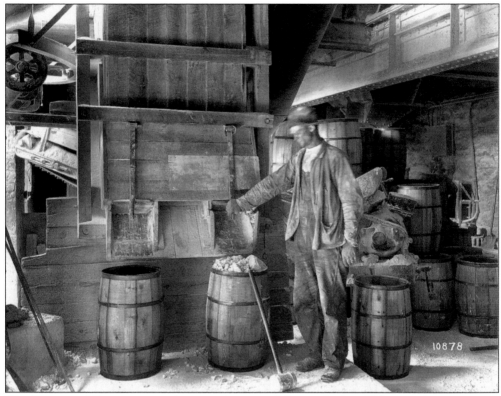

The Carson and Son stone sampling area is pictured during the late 19th century.

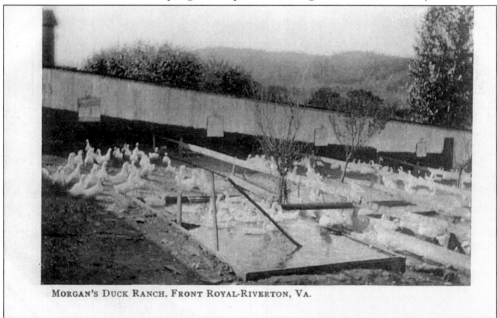

MORGAN'S DUCK RANCH, FRONT ROYAL-RIVERTON, VA.

Morgan's Mammoth Duck Ranch was founded by John Morgan and a member of the Carson family. The fences extended from the ranch on Duck Street to the river. The ranch was a big employer in Riverton and provided ducks for the Philadelphia and Baltimore markets.

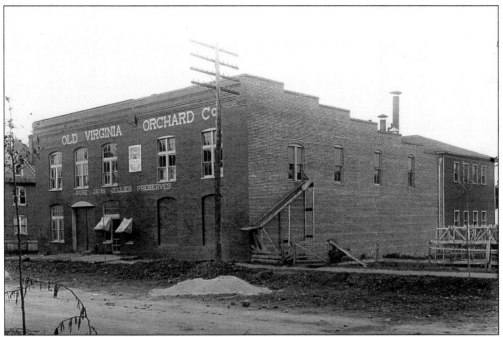

The Old Virginia Orchard Company produced a wide variety of apple products from 1906 through the 1960s. The company was founded by James Baldwin Harsberger in a humble wooden shack. By the mid-1950s the company had moved to a modern industrial complex. Before the development of American Viscose (Avtex), the Old Virginia Orchard Company was the largest employer in Front Royal.

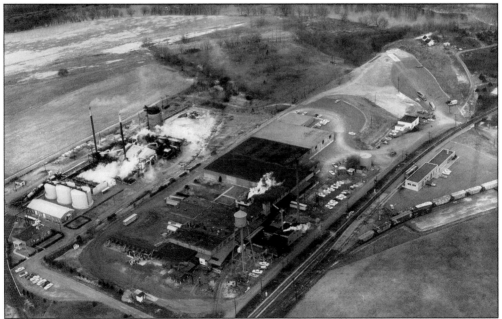

This 1962 photograph features the Old Virginia Packing Company's modern plant. Old Virginia Packing Company was one of the major employers in Front Royal and Warren County. This aerial view was provided by McLaughlin Air Service.

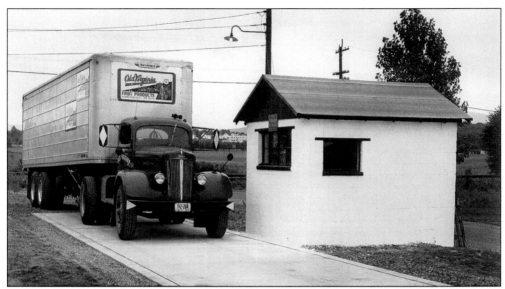

This *c.* 1957 photograph shows the Old Virginia Packing Company weighing station. During the height of its production, Old Virginia Packing produced large volumes of fruit products that were shipped from the plant by a large fleet of trucks. Here, the contents of a truck is being weighed to make certain the load was within legal limits. The photograph was taken by Phil Lance.

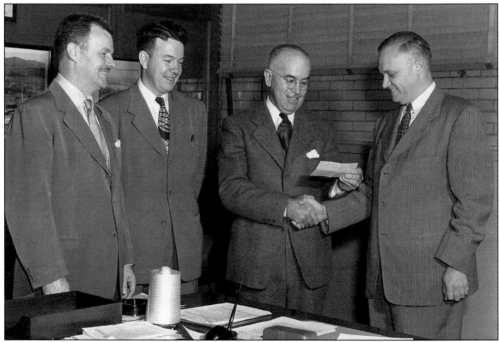

The relatively new Warren Memorial Hospital has a long and interesting history in Front Royal. Around 1928, Mrs. Sidney Johnson opened a nursing home, which was soon replaced by Dr. E.I. Sherman's nursing home in Oakley House. In the early 1940s, the medical community began efforts to open a state-of-the-art medical facility in the Front Royal community. Warren Memorial Hospital was chartered in 1945. This photograph was taken by Margaret Clem.

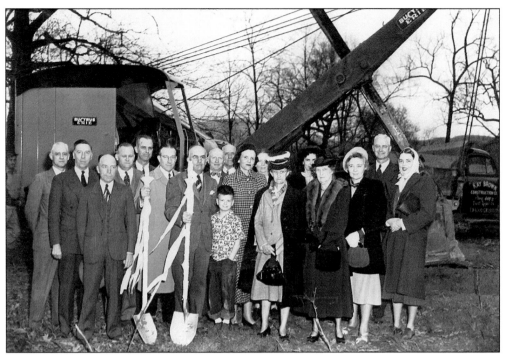

The Warren Memorial Hospital groundbreaking ceremony was held on July 20, 1945. The hospital opened with 48 beds and 10 bassinets and received patients from the Front Royal Community Hospital on January 29, 1951. Included in this picture are S. Payne, F. White, A. Keim, McVay, F. Stoutamyer, G. Tompkins, E. Stokes, R. Millar, A. Guest, Mrs. L. Keyser, Mrs. G. McFall, Mrs. Slaughter, L. Herr, S. Boyd, and S. Hedrick.

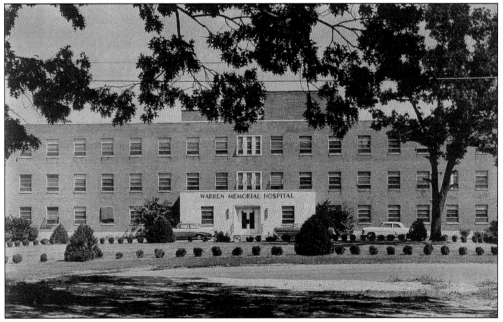

This photograph illustrates the 45-bed Warren Memorial Hospital as it appeared in 1951. Today the hospital has 196 beds and is home to the Lynn Care Center.

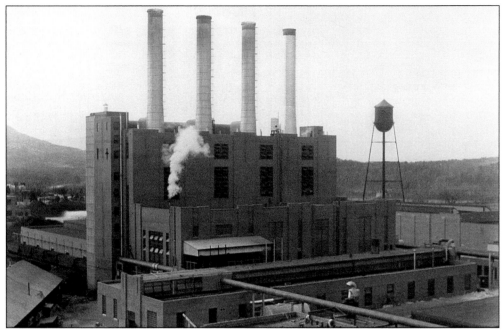

American Viscose Plant began its influence on Front Royal and Warren County in 1939, when it began the production of Vinyon, a new non-flammable, non-absorbent vinyl polymer fiber. The plant soon became a major employer in Front Royal and Warren County, drawing workers from several surrounding states.

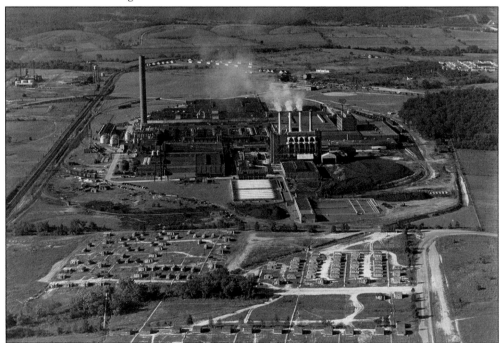

This photograph offers an aerial view of American Viscose Plant during its construction, c. 1945. In the foreground are the trailer villages and construction worker houses occupied during World War II. The plant's production concentrated on fibers used in the military.

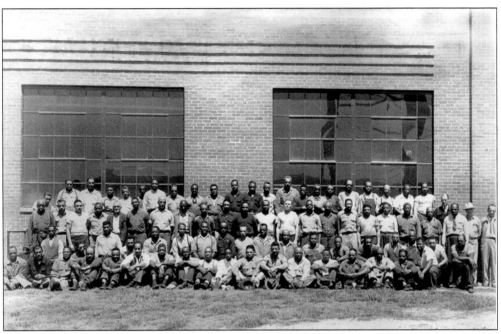

This photograph of American Viscose Plant features the African-American daylight workers engineering department, *c.* 1952. (Courtesy of Paul J. Brooks.)

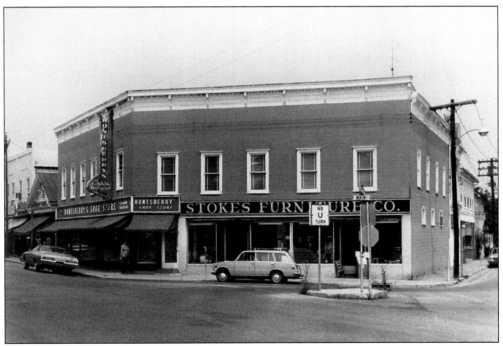

Stokes Furniture was located at 304 Main Street, on the corner of Chester and Main. Today this building is occupied by the Main Street Pawn Brokers. The photograph is part of the *Warren Sentinel* collection.

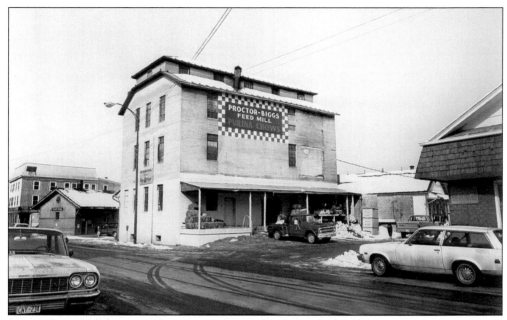

Proctor-Biggs Mill began as the Pettit-Carter Mill. Today the building is the Mill Restaurant. The old train station, the current Visitors Center, is visible on the left. The photograph is from the *Warren Sentinel* collection.

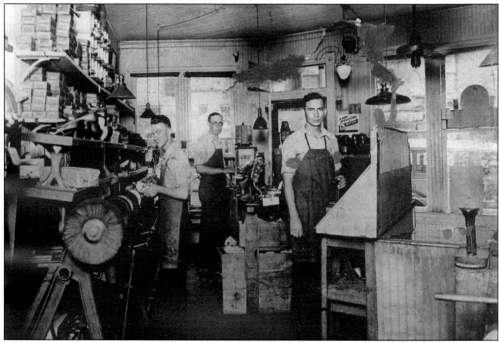

William (Bill) T. Kuser, center, started Star Shoe Repair in 1920 at the intersection of Chester and Main. He was later joined by his cousin Harry, pictured at right, and Woodrow W. Pomeroy, pictured on the left. This picture dates back to the early 1930s. Harry Kuser later assumed ownership and changed the location to Main Street after his shop was burned down in 1969. Harry continued to run this Main Street business until 2002.

The Avtex closing hit the town of Front Royal on November 10, 1989. Although the closing had been expected for some time and the plant had downsized its crew to under 1,500 people, the actual closing was hard on many of the town's citizens.

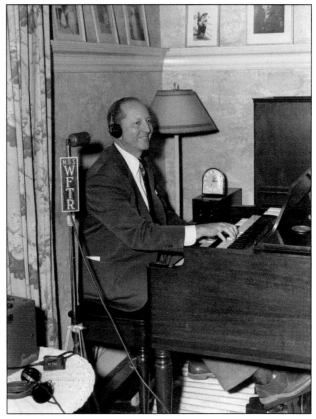

WFTR aired in Front Royal in 1948 as the Sky Park Broadcasting Corporation. On many occasions Edward W. Williams played the piano for telethons and raised money for the March of Dimes and the Community Chest. Williams raised $565 in pledges for the March of Dimes. Edward W. Williams was a mining engineer by profession and moved to Front Royal in 1932 to join Riverton Lime and Stone. This photograph was taken by Leonard A. Durnier.

69

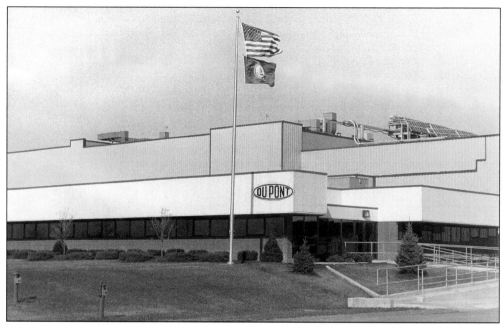

Dupont purchased the 200-acre Gibson farm in 1978 and began production of automotive paints in 1981. Today, Dupont has nine acres under roof and employs approximately 375 people.

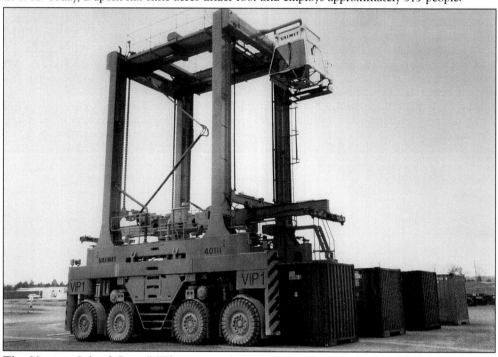

The Virginia Inland Port (VIP) is part of the Virginia Port Authority. This international shipping terminal is located about two miles north of Front Royal with easy access to Routes 66 and 81. The location serves some 75 international shipping companies. The Virginia Inland Port is an official U.S. Customs port of entry. It serves markets in parts of Virginia, West Virginia, Pennsylvania, Maryland, Washington, and eastern Ohio.

Six

AT HOME

Front Royal and Warren County is a splendid place to study the architectural dwellings found in Virginia from the 18th century to today. The houses presented here range from simple settler's cabins to slave cabins to grand plantation homes built by members of the aristocracy. On occasion some of these grand and humble dwellings are open for garden tours. So many of these houses are found in this area that it is impossible to include them all. They speak for the affluence of Front Royal and Warren County before the War between the States.

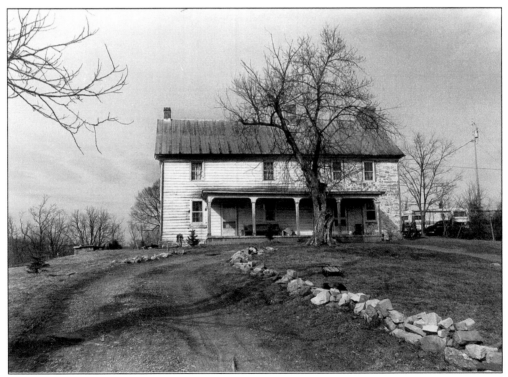

The Robert McKay House is the oldest house in Warren County. Robert's son James married Mary, daughter of Thomas Chester, an early settler who operated Chester's Ferry. A large spring, which produces an ample supply of water for the surrounding residents including the mobile home park, is located nearby. The house, which has been much modified over the years, is still standing on the west side of Routes 340 and 522 at Cedarville.

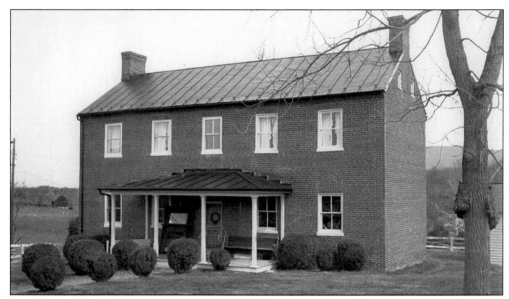

Spangler Hall was constructed as a result of John Calfee's Fairfax grant on Flint Run in 1750. It consisted of a two-story, Federal-style "I" house and a detached, single-story, one-room building. In 1830–1831, Joseph Stover Spangler joined the two structures, creating an eight-room, L-shaped residence with a new brick veneer. Philip Anthony Spangler and Sarah Margaret Spangler lived at Spangler Hall until the early 1900s. Spangler Hall retains its original architecture and has been restored to its 1830s grandeur by current owners, Jackie and David Labovitz. The photograph was taken by R.B. Almy.

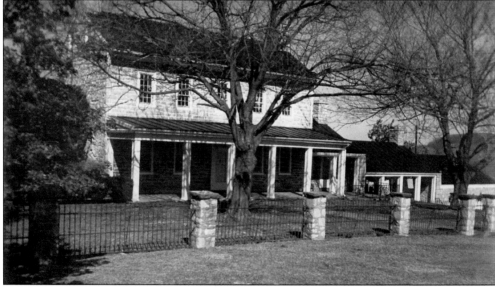

Riverbend Farm was built in 1752 by Col. Thomas Allen. Riverbend (previously called Riverside) retains its glory and boasts 160 acres of river bottom, 20 acres of woods, and 2 miles of river front on the South Fork of the Shenandoah River. The original plaster, woodwork, and pine floors are still in use. A major businessman of the early 1900s, George Ramsey made significant improvements to the house and farm, which he occupied until the mid-1900s. The photograph was taken by R.B. Almy.

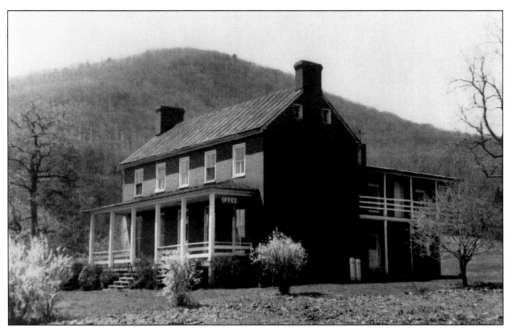

Fortsmouth (1780), named for its location at the mouth of historic Powell's Fort Valley, was built by Samuel Richardson at Waterlick, the entrance to the George Washington National Forest.

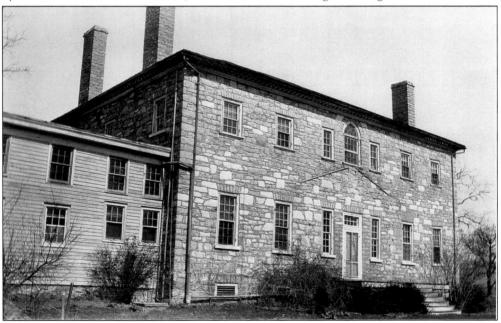

Mount Zion, this Georgian-style house, was built by Rev. Charles M. Thurston from Gloucester County, Virginia. It is made of gray limestone, quarried at Nineveh, and its walls are a stunning two feet thick. Wood-carved moldings and mantels were reportedly created by Hessian soldiers stationed in the area. A secret panel under the stairs was used by Mosby's Rangers. In 1794, Light Horse Harry Lee visited the home. Thurston sold the house to William (Baron) Steenbergen in 1806. It was later purchased by the Earle family in 1840. The current owner is Barbara Frank, who is restoring the house to its original grandeur.

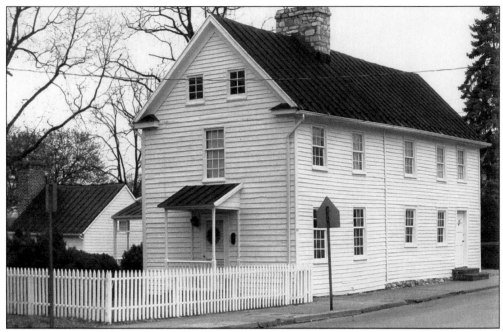

Balthis House (1787) is the oldest surviving landmark on the oldest street in the town. Early occupants Richard Pomeroy and Mary Lehew, granddaughter of Peter Lehew, lived here in the late 1700s, during which time five of their nine children were born. They later moved to Harmony Hollow. Thomas Buck bought the house in 1802. William Balthis, who bought the house in 1838, added the brick wing in the 1840s and the north room in 1855. The Warren Heritage Society acquired the house in 2001 and has plans to make it into a museum. This photograph was taken from the *Warren Sentinel* collection.

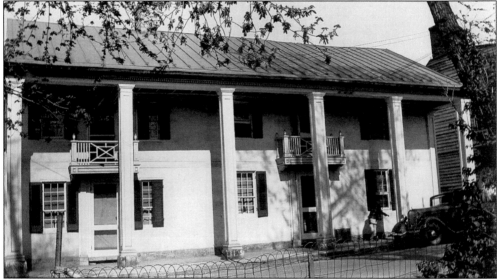

The Trout-Brown House (1780s) was built by one of the town's founding fathers, Henry Trout, a wheelwright by trade. He owned land in the town when it was chartered in 1788. A man of means, Henry Trout had the materials for 82 Conestoga Wagon wheels listed in his estate. The house was converted into apartments in the late 1920s by Dr. Bernard Samuels.

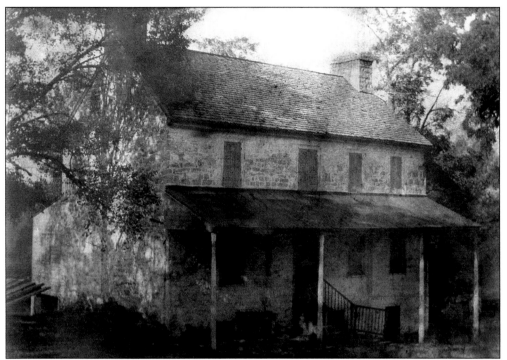

Willowbrook was built in 1780 by Hessian prisoners of war. The house, a stone mansion characteristic of the style adopted by country gentry after the American Revolution, gets its name from the weeping willows that lined a brook on the property. In 1918 R.F. Trenary obtained the property, and it is currently owned by Miss Franks.

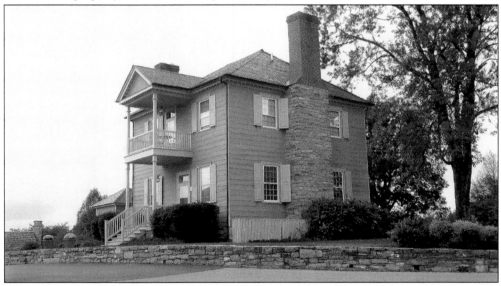

The earliest recorded owner of Fairview is Samuel J. Shackleford. The house was passed on to his two daughters in 1835. The home was owned for at least two generations by Rev. R.B. Shepard, then by a Col. William Shipp, and then by Lynwood L. Morrison's family, the developers of the Shenandoah Golf Club. Fairview is listed on the Virginia Landmarks Register of Historic Places and is today maintained as a bed and breakfast. (Courtesy of the Shenandoah Golf Club.)

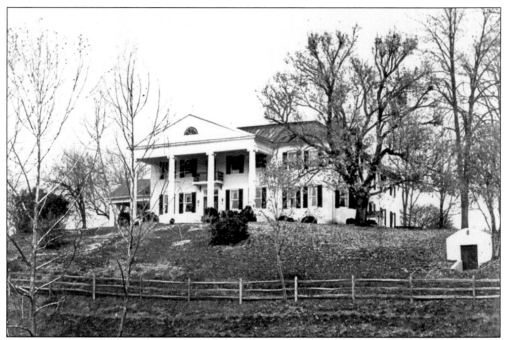

Bel Air was built on land purchased by Capt. Thomas Buck. Captain Buck built two log cabins, consisting of two rooms each, in 1795, and proceeded to build the brick portion, which he occupied in 1800. Bel Air was purchased from the Bucks by S. Byrne Downing in 1905, who, in turn, sold the property in 1973 to Larry LeHew. The LeHews have restored, refurbished, and added rooms to the home over the years.

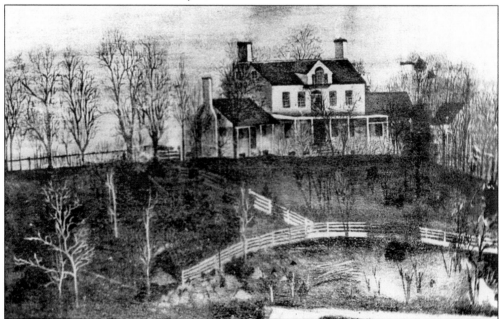

This photograph is from a sketch of Bel Air, as it appeared in 1862, when Col. Bradley T. Johnson stopped there for tea. Gen. Robert E. Lee also stopped at Bel Air for buttermilk on his trip home from the Battle of Gettysburg. Lucy Buck's diary records General Lee's visit.

Guard Hill was possibly built by Isaac Longacre between 1821 and 1834. The land was an original Jost Hite patent and was the site of the Thomas Chester ferry landing. During the Battle of Front Royal, Union cannons were aimed at Guard Hill. Guard Hill is currently occupied by Bill and Cee Ann Hammack.

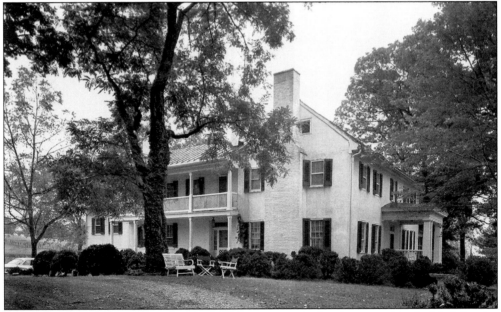

Rose Hill was built in 1825 by George C. Blakemore on the land given to him by his father-in-law, Thomas Buck. The original house was built out of log and clapboard. The house played a key role in the Battle of Front Royal. CSA Major Wheat led his Louisiana troops in a swift victorious attack from the crest of the hill on which Rose Hill sits. Susan Richardson stood in one of the front windows and watched Union soldiers execute Henry Rhodes in front of his aging mother and recorded the sorrow she and all of Front Royal experienced. Today Rose Hill is occupied by Ron and Corinne Llewellyn. The photograph was taken by Lewis E. Allen.

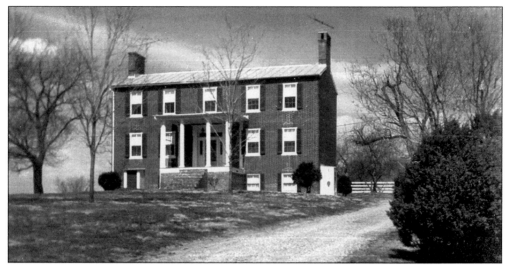

Liberty Hall was built in 1841 by William Woodward, a veteran of the War of 1812. The house sat on 7,500 acres. Woodward's initials, along with those presumably of the builders and other family members, and the date 1841, are carved on the eastern and western chimneys. This Federal-style home is made of brick and is currently owned by Richard and Catalina Hoover. The photograph was taken by R.B. Almy.

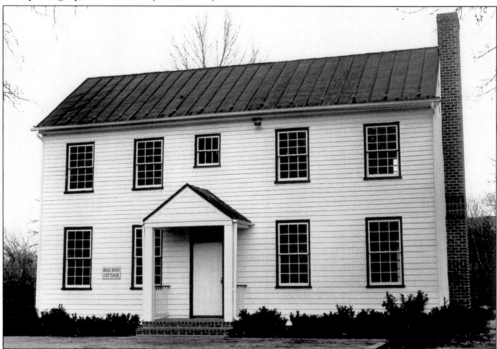

Belle Boyd Cottage was constructed around 1842. Architect Warren McNamee has concluded that the cottage may have been one of the pre-fabricated houses sent from England during the post-Revolutionary years. Originally located behind the Fishback Hotel, the cottage was occupied by the Stewarts in 1861, when their niece, Belle Boyd, was sent to live with them. She used the house as the center of her intelligence activities. Information gathered at the cottage was supplied to Gen. Stonewall Jackson before the Battle of Front Royal on May 23, 1862.

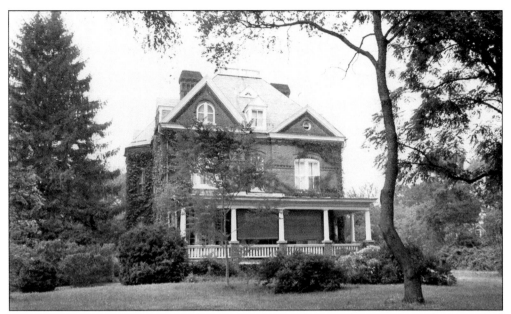

Though Dellbrook Manor's date of construction is unknown, by 1878 Samuel Carson had purchased the land and construction began. The house is Queen Anne–Victorian style, made of bricks brought from Carson's native Ireland as ship ballast. Since its construction, Dellbrook has served as a private residence of the Carson family, a nursing home, and the campus of the Roller Business College and the Amos R. Koontz Memorial Foundation. The house is currently a bed and breakfast. The photograph comes from the *Warren Sentinel* collection.

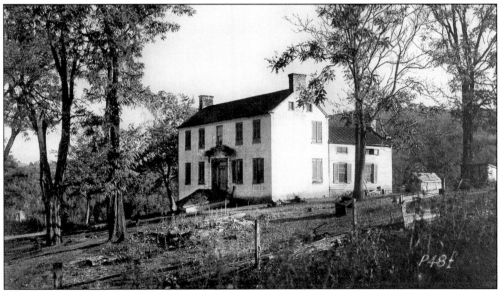

Belmont was built by Marcus Buck in 1847. A pioneer fruit grower in the Valley, Buck grew peaches, but by the end of the Civil War, he was sending most of his crop to the still. A lack of transportation had nearly put him out of business. After the war, the farm shifted to grapes. Two of his sons, William Walter Buck and Richard Bayly Buck, served in the Confederate States Army. The Laura Virginia Hale Archives is in possession of journals covering their war experiences.

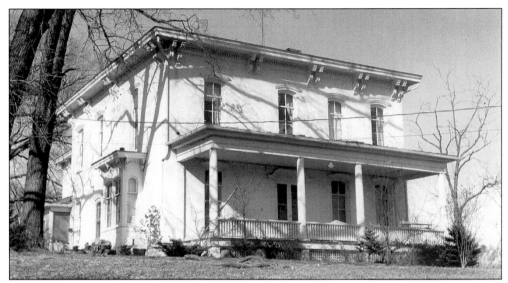

Lackawanna was built in Victorian-Italianate style in 1869 by Dorastus and Martha Cone. Mr. Cone was one of the owners of Riverton Mill. The house was fitted with all the modern conveniences of its day, including gas lights and hot water in the four upstairs bedrooms. The Cone family reportedly installed the first telephone in the South at Lackawanna. The house was purchased in 1998 by Philip and Sandra Charles, who operate Lackawanna as a bed and breakfast. This photograph came from the *Warren Sentinel* collection.

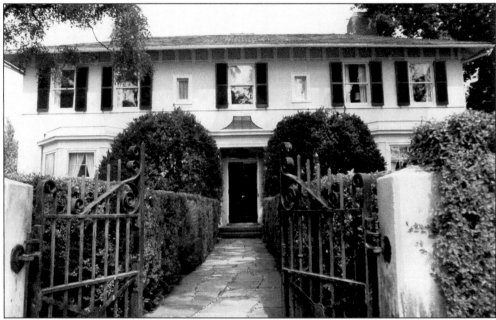

Chester House was rebuilt in 1905 by the Samuels Family. It was originally called the Boone-Samuels Home. The older portion of the house, which dates back to 1848, was incorporated in the rear of the present structure. Kathleen Boone and Green Berry Samuels Jr. were married here in 1862, and, after the war, their marriage was covered in the book, *A Civil War Marriage*, written by their children. Dr Bernard Samuels was the last of his family to own Chester House. It is now a bed and breakfast. The photograph was taken by Charles Newlon.

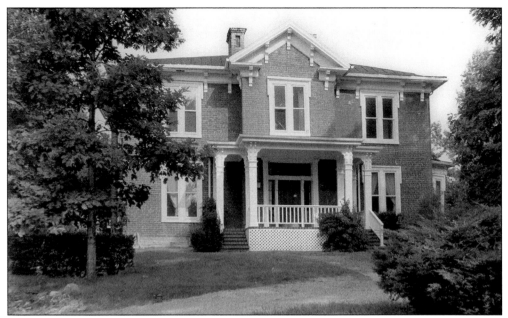

Oakley, which was built between 1855 and 1857, was purchased by Mr. and Mrs. George Macatee in 1878. During the Macatee occupation, Catholic services were held at Oakley until construction of St. John the Baptist Roman Catholic Church was completed. The front room, with its large bay window, was fitted out as a chapel. Starting in 1939, it was used as Johnson's Nursing, a first-class maternity hospital. Oakley is currently a private residence.

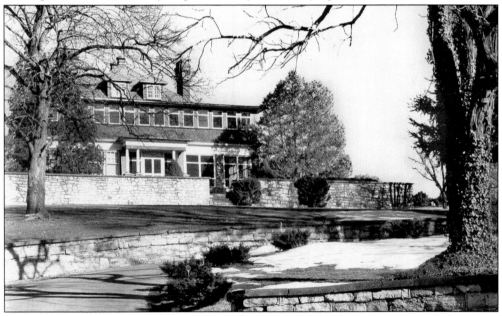

Killahevlin was built by William Edward Carson, an Irish immigrant and limestone baron. William Carson arrived in America in 1885 at the age of 15 and was the first chairman of the Virginia Conservation and Development Commission. Near this building is the site of the hanging in 1864 of six of Capt. John Singleton Mosby's Rangers. Killahevlin is now a bed and breakfast.

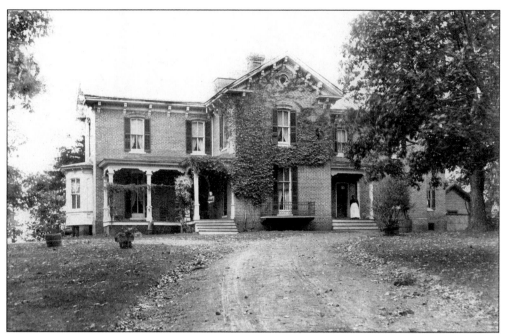

In 1872 Druid Hill was built in the shape of a cross by Samuel E. Macatee and Roberta Gardner Macatee in American bond brick. The property was purchased in 1917 by Gen. and Mrs. Beverly F. Browne, who resided there until her death in 1978. Druid Hill was purchased by Mr. and Mrs. C. John Costello in 1982.

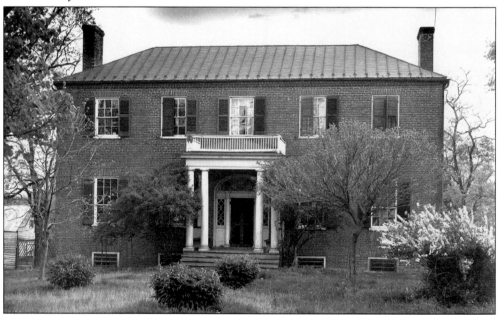

Sherwood House was a brick, two-story dwelling built around 1875 by Capt. James Timberlake. His daughter married John Thomson, and the house remained in the Thomson family until after World War II, when it was sold to Harvey Shaffer. Mr. Shaffer's daughter, Ann, sold it to the daughter of Paul Mellon, Kathy Mellon Conover. The house and its slave cabins burned shortly after World War II. The photograph was taken by Lewis E. Allen.

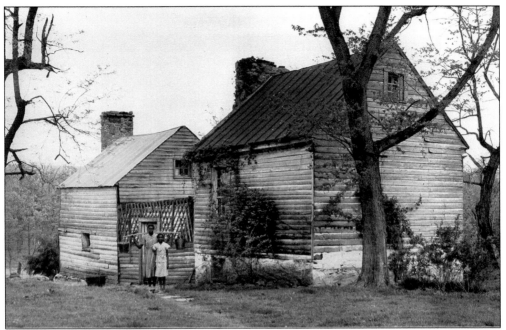

Slave cabins located immediately behind the Sherwood House are shown in this photograph from 1940, at which time they were used as tenant farmer houses. The photograph was taken by Lewis E. Allen.

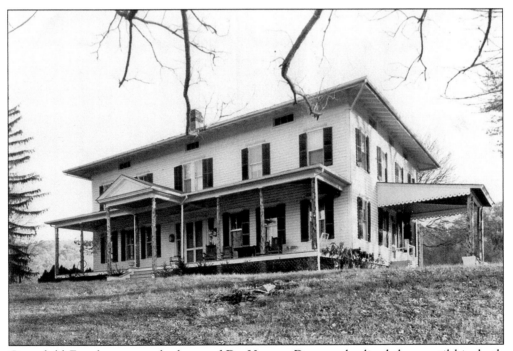

Greenfield Farmhouse was the home of Dr. Hanson Dorsey, who lived there until his death in 1879. It was sold to Gen. Hubert Dilger in 1901. Mr. and Mrs. Thomas R. Owens upgraded Greenfield to a guest house around 1937.

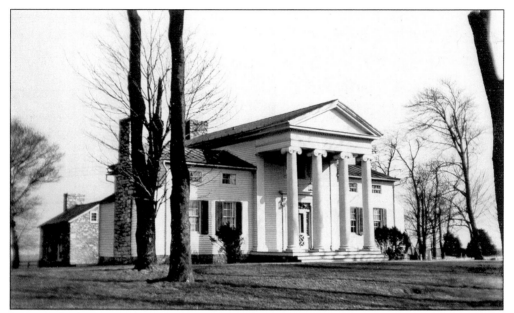

Erin was built in 1840 by David Funsten. The original portion of the house is made of log. When the family finished construction it was a fine example of Greek Revival, dominated by an Ionic portico. The kitchen was probably built a century before Erin and served as a home for the family while the main house was constructed. The photograph is courtesy of Mrs. W.C. Trenary.

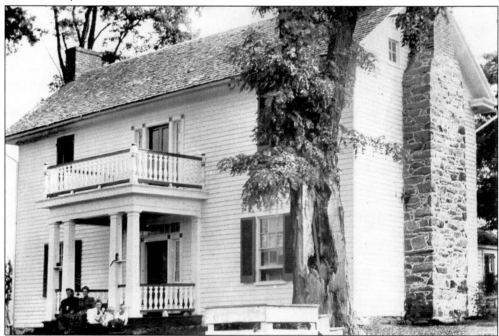

This house was built by the Hansbrough family, who owned the land during the late 1700s. The house has served as a tavern and a stagecoach relay station, and at one time it contained a mill and a store. After the Battle of Wapping Heights in July of 1863, the house served as a hospital. This photograph was taken before the house was enlarged in 1895.

Seven

AT PRAYER

Today virtually every major denomination has a house of worship in the Front Royal–Warren County area. This has not always been the case. The first settlers included Quakers, Lutherans, and Calvanists. In time many of these congregations, which shared houses of worship, became Baptist, Presbyterian, and Methodist, the early religious communities in this area.

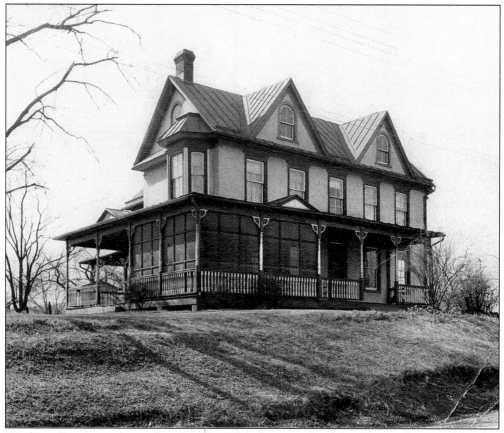

Woolston Residence, located at 108 West 13th Street in Front Royal, was the site of the first meeting of the Church of the Brethren.

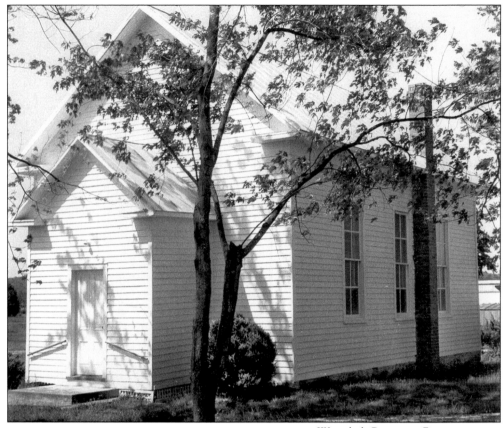

Waterlick Primitive Baptist Church dates back to 1788. Its records are the oldest in the area, because they were hidden during the Civil War.

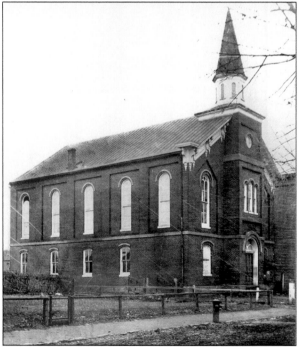

The first Methodist chapel, built in 1792, was a log structure on the corner of Main and Church Streets. The building was replaced in 1833 and 1880. By 1900 the Methodists had outgrown the old sanctuary and moved to the current location on North Royal Street. The original church was renovated and given a new lease on life, without the steeple, as the Murphy's Theater.

Zion Baptist Church first appears in local records in 1797. Much of the building is in its original state, dating back to the time in which men and women entered by separated doors and sat on separate sides of the church. The old pews and kerosene lanterns on the pulpit and the hardwood floors have never been touched with a finishing agent. It is believed that Zion Baptist Church is the oldest still standing church in Warren County.

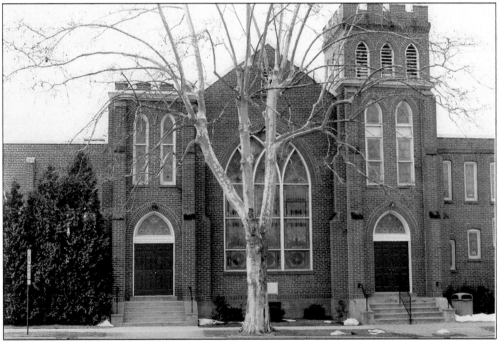

The First Baptist Church was organized by eight members of the Front Royal Missionary Baptist Church. During the Civil War, the congregation worshiped at the Episcopal church on Main Street. The congregation moved to a new location on Crescent Street in 1874 and began construction of the present church in 1913.

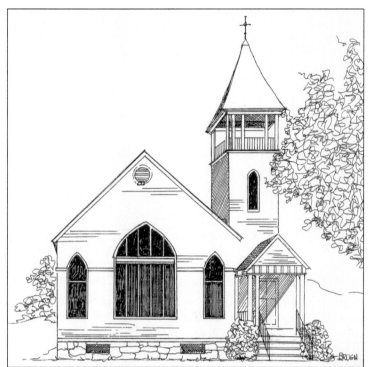

Browntown Baptist Church is situated on the land originally purchased by the Evangelical Lutheran Synod in 1897. The Baptist congregation purchased the building from the Lutherans in 1943. The original drawing, done by Brugh and found in the Rebecca Poe files, was donated to the archives by the *Warren Sentinel*.

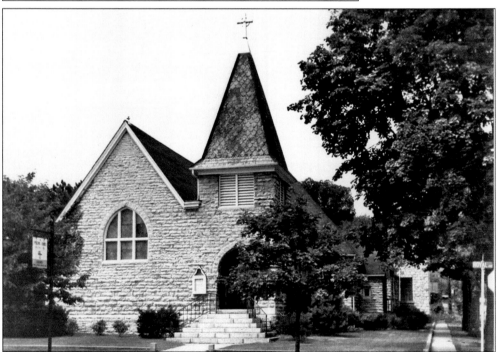

The Calvary Episcopal Church congregation met in the Methodist church until 1856, at which time they built their own place of worship on Main Street. This building burned in 1892. The congregation then obtained land on the corner of Second Street and North Royal Avenue. The new structure was completed in 1898.

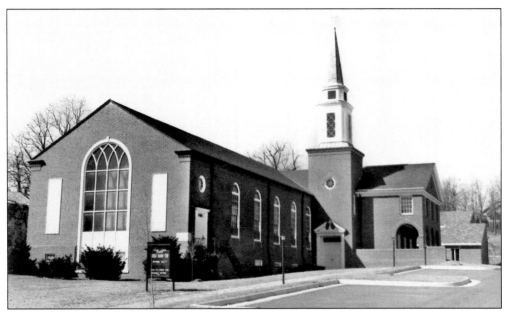

Presbyterian worship began in November of 1794, early in the history of Warren County and Front Royal, in cooperation with the Old School Baptists. This cooperation continued until the Presbyterians constructed their first formal place of worship on South Royal at Jackson Street. The current Presbyterian church was built on Luray Avenue in 1958 and was consecrated in 1959.

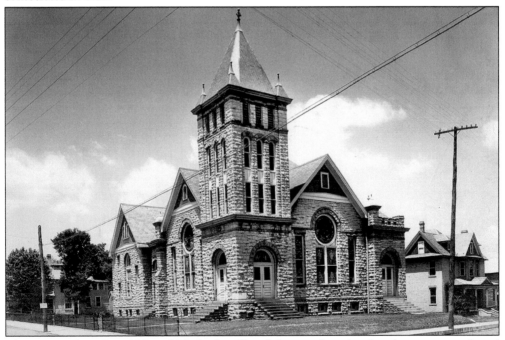

The current Front Royal United Methodist Church began when the church trustees purchased a new lot on Royal Avenue in 1903. The cornerstone for the new building was laid in 1905, and the first service was held on May 23, 1909. The church was not dedicated until the debt was paid off in 1915.

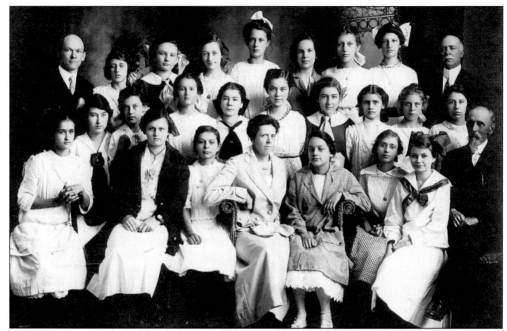

Front Royal United Methodist Church Women's Class of 1913 to 1917 offers a look at the early congregation of the new church, constructed between 1905 and 1909. Methodists have long been known for their lay leadership in education. Such prominent educators as Q.D. Gasque, Col. John Boggs, Leslie Fox Keyser, and Dr. H.H. Sherman attended worship in this church.

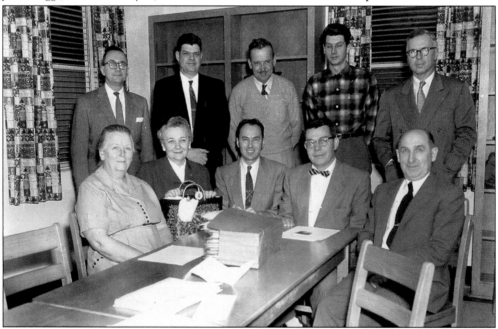

The Front Royal Methodist Building Committee met from 1954 to 1955 to plan for a new educational building. From left to right are the following: (seated) Leslie F. Keyser, Lucille C. Herr, Roland Ridings, Max Gooden, and Ed Collins; (standing) Harry Wilson, Reverend Forrester, Elmer Harris, unidentified contractor, and Jack Baldwin.

Mt. Carmel Baptist Church began as The Indian Hollow Baptist Church in 1891 and burned in 1922. A church building was given to the congregation by a man in Browntown and was moved from Browntown to Bentonville in 1923. The congregation remodeled the building and dug a basement under the sanctuary. The big event at Mt. Carmel Baptist Church is the annual homecoming, held in the second Sunday of June. This photograph was taken by Wendy Jones.

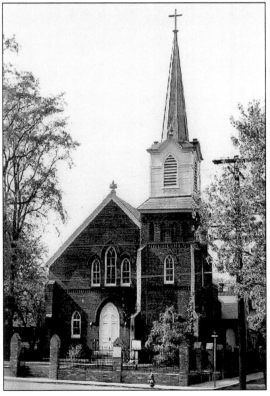

St. John the Baptist Catholic Church was dedicated in 1884. Funds for the construction were provided by a fallen Confederate soldier from Baltimore, John Carrell Jenkins, who spent some time in Front Royal and knew that the town needed a Catholic church. In the late 19th century, the Macatee family opened their home on Chester Street for worship and later converted the parlor at Oakley into a chapel. Land for the church was taken from Oakley in 1882. The church was dedicated in 1884. In 1998, a new church was dedicated. The original church, pictured here, is used for perpetual adoration.

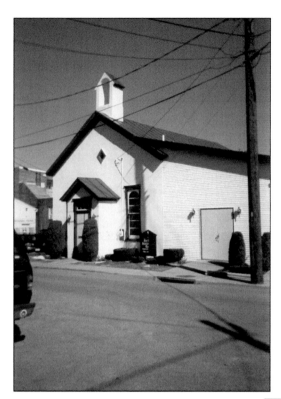

John Wesley United Methodist Church was founded following the Civil War, when the African Americans who attended the Front Royal United Methodist Church on Royal Avenue decided to found their own church. It has served the community since 1869.

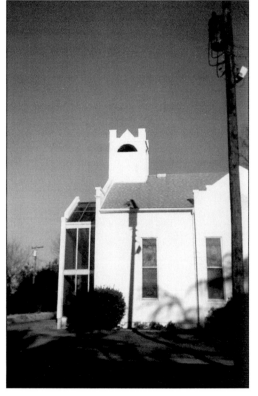

Reliance United Methodist Church made its historical debut as a building constructed by the United Brethren in Christ, who first built a place of worship on the site around 1840. The first the building was shared by several denominations. The present building (pictured) was built in 1887. This photograph was taken by Wendy Jones.

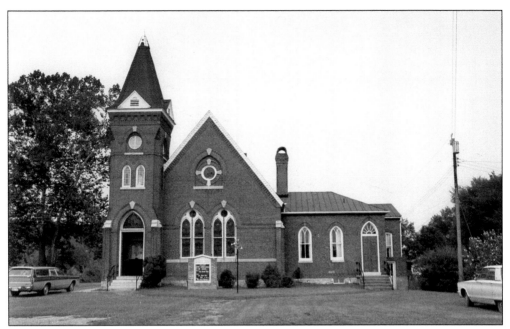

Riverton United Methodist Church was built in 1882. Unfired bricks for the structure were brought from Ireland by Samuel Carson and fired in the yard. By the 1990s, the congregation had outgrown the old church. Services were first held in a new church on December 9, 2001. A school located in the new church currently houses pre-school through seventh grade.

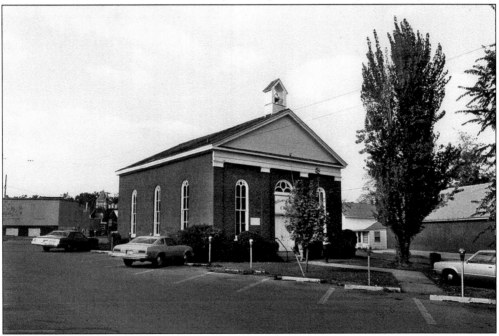

Williams Chapel, built in the 1840s by the Presbyterians, served as the Warren County Courthouse during the first year of the Civil War. In 1883, Belle Boyd gave a performance of her "Perils of a Confederate Spy" in the chapel. In 1898, the church was sold to the Christian Methodist Episcopal Church and has been a leader in the African-American community ever since.

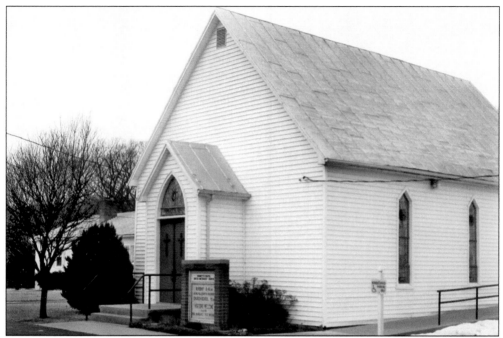

The first house of worship built on this site was constructed of log in 1847. Bennett's Chapel United Methodist Church was rebuilt in 1886, after the old church in the Fork area was destroyed by fire. The lumber for the new church was brought up the river by four barges and construction took two years to complete.

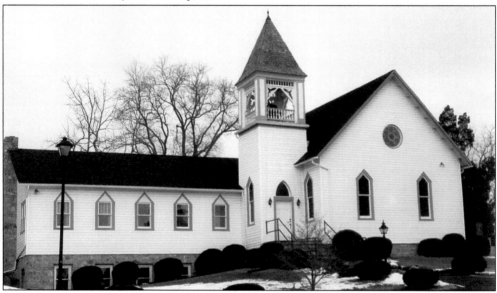

Nineveh Presbyterian Church is located on land that has long been used for worship purposes. The Quakers first met there between 1758 and 1810. The Nineveh Presbyterians organized in 1882 with 18 members. A new church was built in 1893 at the cost of $1,800. In 1913, the church was struck by lightning and burned to the ground. The current building was constructed and dedicated on July 11, 1916. The Virginia Historic Landmark Survey refers to the church as a fine example of country Gothic Revival architecture.

Asbury United Methodist Church was originally built in 1844 by Jack Ramey. Col. Isaac Newton King, leader of the "Union Class" in the 1830s, and the members formed the nucleus of the Asbury Church. This is the same Isaac Newton King who was sitting on the fence at Asbury when General Stonewall asked him for a better route into Front Royal, just prior to the Battle of Front Royal in 1862. The church served as a hospital during the Civil War and was rebuilt in 1916. This photograph was taken by Wendy Jones.

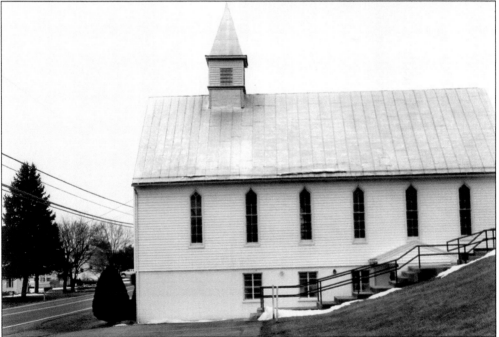

Bentonville Baptist Church was constructed on land sold to the congregation for $50 in 1893 by Robert and Mary Compton. The congregation was organized in 1878. During the early years, several denominations shared the sanctuary. This photograph was taken by Wendy Jones.

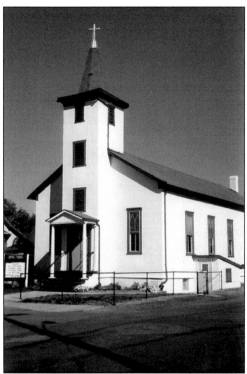

Mount Vernon Baptist Church was formed in 1865 from a number of African-American religious communities. The lot on which the present church is situated was purchased in 1882. The church was enlarged in 1903. Mount Vernon Baptist Church has served the African-American community for over 139 years.

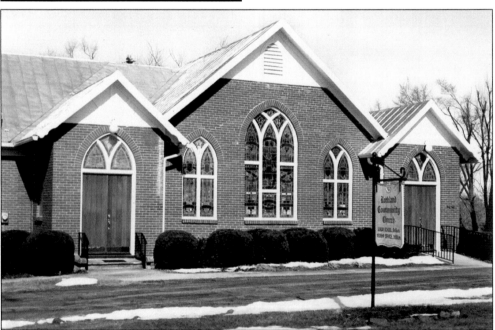

The first church built at Rockland was jointly constructed in 1780 by the Lutheran and Calvinist communities. It was known as a "free church" because other denominations were free to use the sanctuary. The Rockland Community Church remains a unification of several denominations and was dedicated in 1879. The Community Church, established by the Methodists and Baptists of Rockland, was united in 1948. (Courtesy of the Rockland Community Church.)

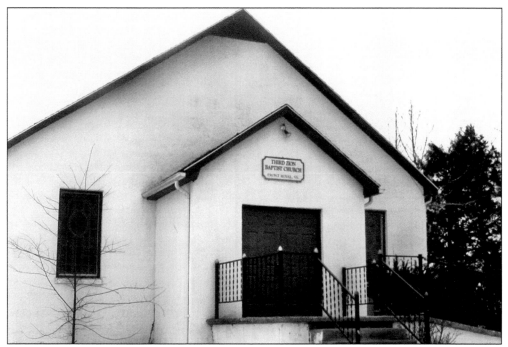

The Third Zion Baptist Church is located in the industrial park, north of Front Royal. The church was originally located on Winchester Pike and was moved a half-mile off the road in the 1920s. The building was destroyed by fire in 1965 and rebuilt on the same site. Third Zion has served the African-American community of Success for many years.

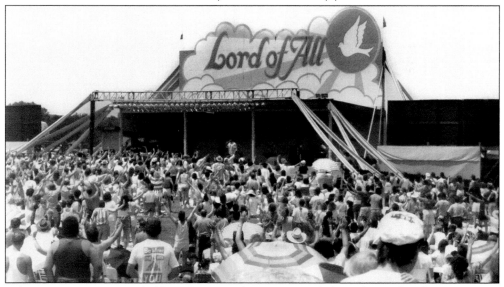

Fishnet Ministries, Inc., held its first non-denominational festival in July of 1975. During the height of their popularity, the festivals drew as many as 18,000 people to a single event. In 1992, Senior Pastor Larry D. Andres and his wife Bobbi Andres founded the Fishnet Christian Center, which is currently a thriving congregation. The worship center is multipurpose and includes a gymnasium, sanctuary, classrooms, and an office complex. (Courtesy of the Fishnet Ministries.)

The Limeton United Methodist Church dates back to the donation of the land in 1889 by Elias and Elizabeth Herr. Elias's brother Benjamin moved to Limeton from Pennsylvania and established the Limeton Lime Company. Church construction began in 1890, and the new church was dedicated in June of 1893. The interior of the church was remodeled in 1959.

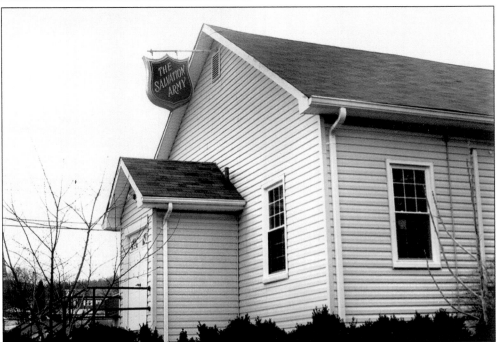

The Salvation Army first came to Front Royal in 1952. The first chapel was occupied in 1955. The congregation moved into former First Church of God building, purchased in 1972. The Salvation Army still occupies the Cloud Street building pictured here.

Eight

AT SCHOOL

The exact year when the people of this area became concerned about the education of their children was not recorded. Early efforts most likely were conducted at home and at church. An indication that such efforts were early was the founding of the Front Royal Community Library Society, the second such library in Virginia. The first Sunday school was established by Spencer LeHew a year later. In 1814 the first formal school was affiliated with the Happy Creek Baptist Church and conducted by Samuel Simpson. By 1845, 26 common schools existed in Warren County, and in 1847 the Royal Academy opened on Crescent Street. Around 1855, 28 "Old Field Schools" were located in Warren County with a total of 306 students attending. That same year Stephen Decatur Boyd ran a private school at Gooney Manor Plantation, and Dr. Charles Eckart Newton offered piano lessons in Front Royal. We have no record of any school being conducted here during the War between the States. The first school to open after the war was the Stonewall Institute.

The Stonewall Institute was run by Mr. G.E. Roy, the eventual superintendent of Warren County Public Schools, at his home on South Royal Avenue. The institute operated from 1869 to 1872 and was co-educational, though the sexes studied separately. The building is still standing and is currently being used as an apartment building. This pen and ink piece was done by local artist and historian, Janice Imper Long.

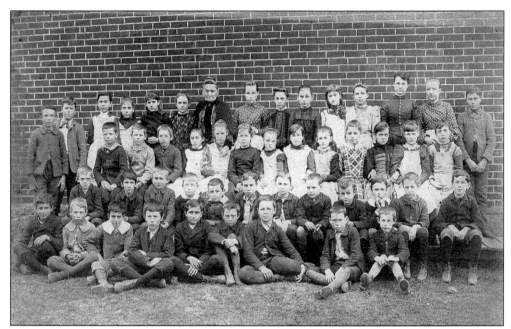

This class photograph of Mary Simpson's Front Royal Graded School class of 1890 shows a small portion of Miss Simpson's many students. Miss Simpson is pictured in the center of the back row. She was described by one of her students as "a whacking good teacher who made her mark on many of the town's older residents." Her students studied subjects such as geography, orthography, civil government, physiology, history, arithmetic, hygiene, and grammar.

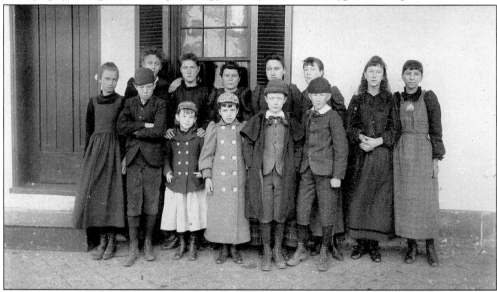

Shown here are some of Miss Brucie Trout's students at the Front Royal Graded School. Miss Trout was one of the original teachers at the Front Royal Graded School, Warren County's first public school. In 1877, Superintendent Roy said, "I called in at Miss Brucie Trout's school and found nearly forty little fellows about the same age and size in pretty close quarters. My sympathies were elicited for the teacher in charge, as one bearing more than her portion of the burden." Miss Trout is pictured on the far right.

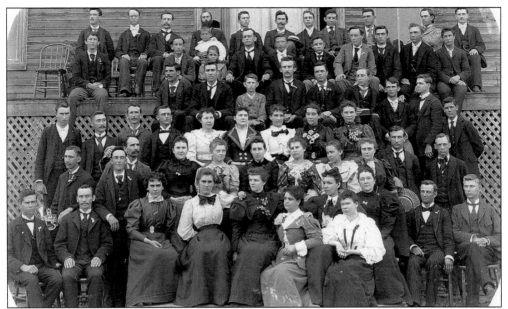

Shenandoah Normal College moved to Warren County in 1892 and opened in 1893. After a devastating fire in 1914, the school closed permanently. Shown seated, second from the right, is J.S. Grover, the founder of Eastern College, also located in Front Royal. Calvin Beaty is in the far right section of the second row, holding a trumpet. Laura Virginia Gruver is the second woman on the left in the second row. (Courtesy of Joyce Gruver Dunlap.)

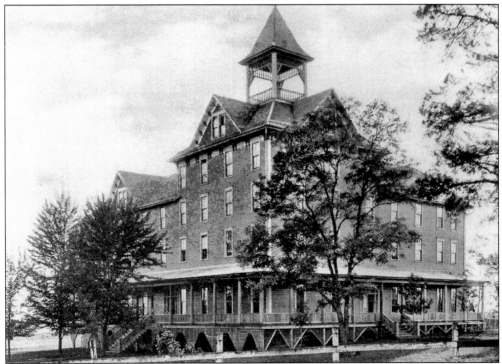

The former Shenandoah Normal College became Old Dominion Academy in 1910. This photograph was taken not long before the fire of 1914.

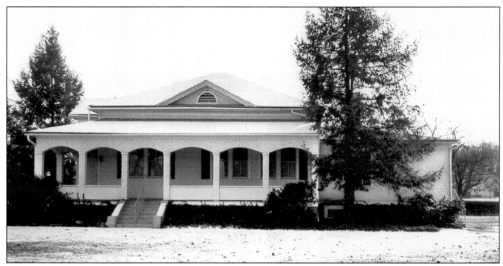

The Holcombe Institute was founded by Alice and Lettie Holcombe at the intersection of Lee Street and Luray Avenue in 1890. In 1892, a local newspaper wrote "The Misses Holcombe School may now be called a Front Royal institution, so rapidly has it grown and so well established has it become." Many local educators taught or were instructed at the school. The school closed in 1900, and the building was purchased by George Ramsey, who turned it into a private home. Today it is known as the Thompson House.

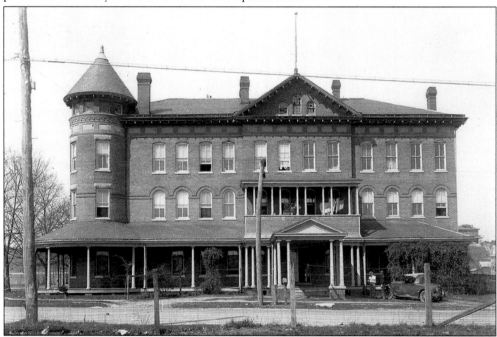

Eastern College was founded in 1900 at Sixth Street and North Royal Avenue. It was originally a hotel. The 1901 college catalogue praised of Eastern's architecture in saying, "the college buildings are magnificent brick structures. No money has been spared to make them rank among the finest school properties in the country." After Eastern's main building burned in 1908, the college relocated to Manassas. The building reverted to its original use as a hotel until it was torn down in 1964.

Eastern College was open to both men and women. The 1901 school catalogue promised that, "The private rooms are large, airy, and handsomely furnished. The floors of all rooms are carpeted, and each contains an elegant suit of furniture. The beds are supplied with the best mattresses, springs, feather-pillows, and bolsters." Boarding students paid $52 for the fall term, $46 for the winter, and $37 for the spring term to enjoy the lifestyle and academics offered at Eastern.

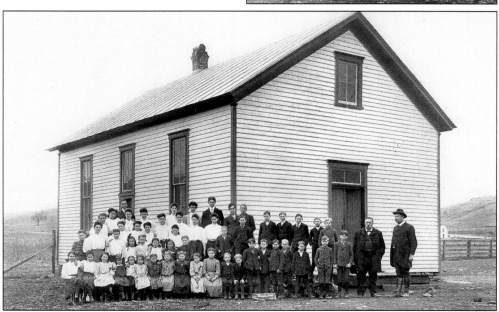

This photograph of Browntown School was taken in 1906, when all Warren County schools were photographed for display at the Jamestown Exposition. Small one-room schoolhouses were the norm in Warren County. In 1906, the majority of Warren County's 1,200 students attended such schools. The teacher, Miss Genevieve Cockrille (later Mrs. Bishop), is the first person on the left in the second row.

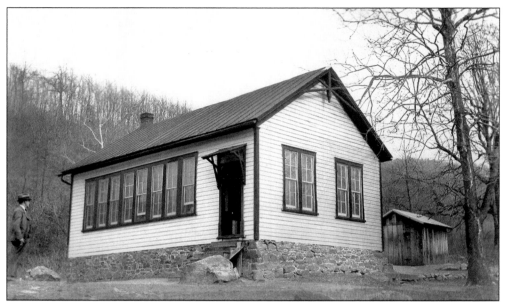

Harmony Hollow School was located in the Harmony Hollow community at the headwaters of Happy Creek. The school was built in 1892 and remained in use until the early 1950s. After closing, it was sold at public auction in 1960 when J. Edwin Hickerson, a former student, purchased the building. He recalled that the school had two doors, a back door and a front door. The girls used one door, while the boys used the other. The building was heated by a large stove.

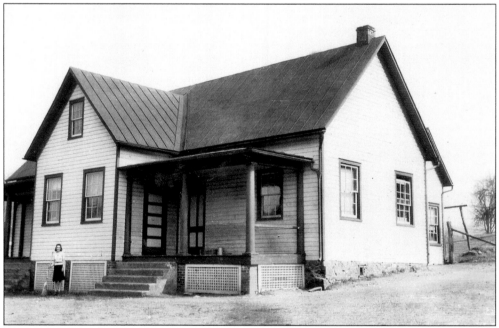

The children who attended the Linden School were given a rare opportunity in rural Warren County. Linden School was a two-room public elementary school that served grades one through seven from 1870 until the early 1960s. When the school closed, after much debate in the 1960s, its students were transferred to a larger school, A.S. Rhodes, in Riverton. The building shown here was constructed in 1917.

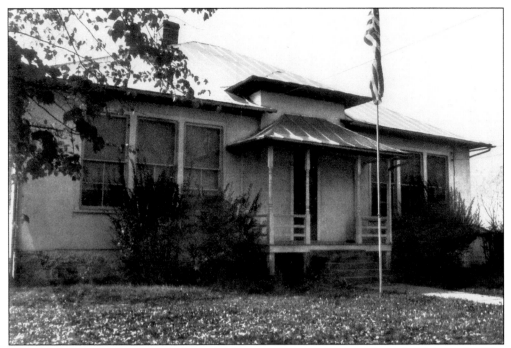

The Bentonville School was built in 1914 to serve a community of nearly 200 people. The contents of the school were sold at a public auction in 1980. Today elementary-aged children from Bentonville attend one of the five elementary schools in the county.

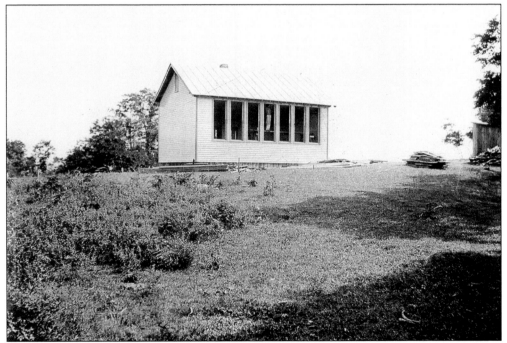

The Waterlick School served a small community in an area of the county known as "The Fork." The village's population in 1912 was a mere 45. This small schoolhouse served the village's children.

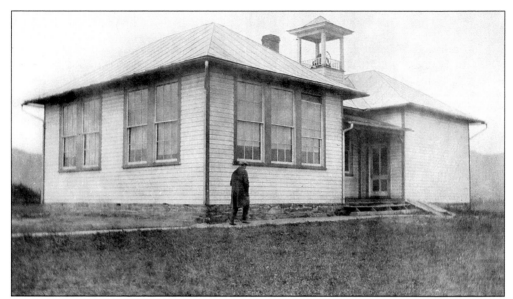

The Otterburn School, built in 1911, was located on Rivermont Drive, near Front Royal. In 1960 the school was remodeled to include two classrooms, a reading room, and inside bathrooms. When it closed in 1977, the school offered only kindergarten through second grade. At its height of activity, in 1949, Otterburn School had three teachers and two teachers' aides.

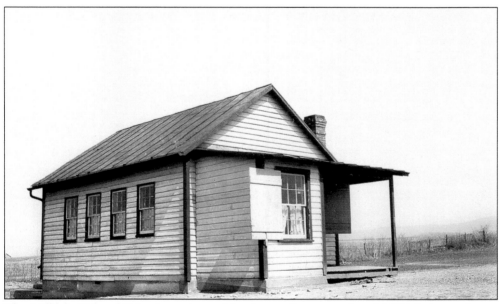

The Milldale Colored School was located in the small community of Milldale in northwest Warren County and was built in the early 1900s. In 1906, the Milldale school served some of Warren County's 180 African-American students. The school's small size and construction was typical of the county's many rural one-room schoolhouses built around the turn-of-the-century.

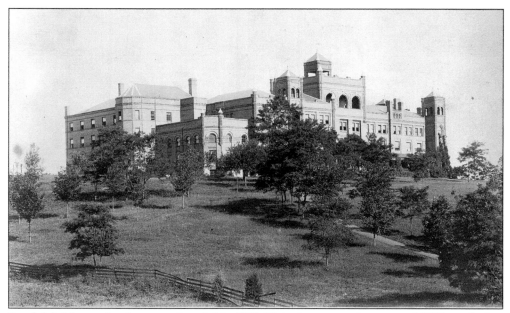

Randolph-Macon Academy was founded in 1892. This photo was taken around 1926, just before the fire of 1927. The *Baltimore American* told its readers that it was "a magnificent building, believed to be the finest academic building in the South—a credit to the town of Front Royal and an educational advance of great value to the State." Today the Randolph-Macon Academy retains a strong presence in Front Royal. Its 135-acre campus sits on a hill overlooking the town.

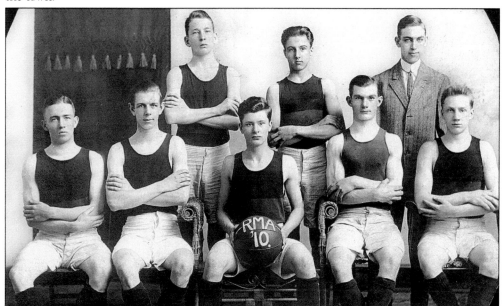

Randolph-Macon Academy's mission has long been to nurture the mind, body, and soul. In addition to offering physical education classes, the school encouraged students to play a team sport. In 1910 there were no official leagues, but schools did occasionally travel to local towns for games. The 154 students of 1910 could choose to play basketball, football, tennis, or baseball. This photograph features the basketball team.

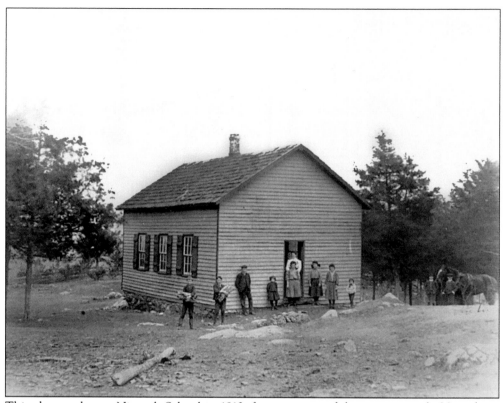

This photo, taken at Nineveh School in 1912, features some of the approximately 20 students in attendance. The school was open to grades one through seven. Students at the school were part of a small community, as Ninevah had approximately 80 residents at the time.

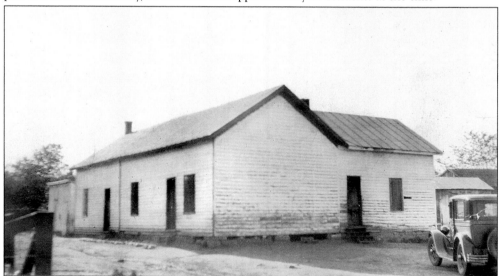

This three-room schoolhouse, located at Laurel and Osage Streets in the South Town neighborhood of Front Royal, was one of the eight schools that served local black children during the early 20th century. Mrs. Ressie Jeffries, a well-loved and respected local educator, began her lengthy career here in 1913. The Warren County Colored School was closed 1932.

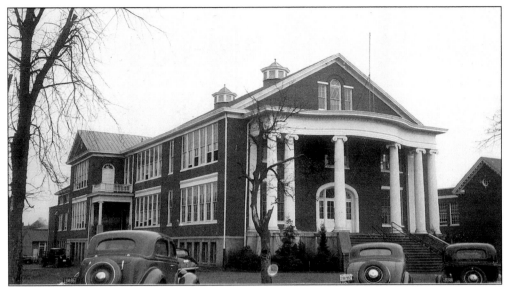

Front Royal High School, which later became Warren County High School, officially opened in 1906 with 97 pupils. The school moved to Crescent Street in 1910. In 1927 the school added an eighth grade, making Warren County one of the first counties in the state to move to the 12-year grade system. In 1940 the county's high school moved from its Crescent Street address to its new home on Luray Avenue. Three years later, on December 23, 1943, the Crescent Street school was destroyed by fire.

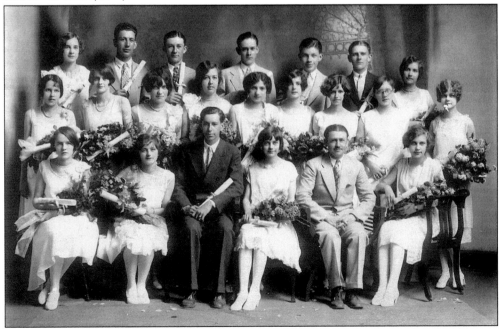

This Warren County High School Class of 1926 graduation photo captures the school's sense of pride. The 1925 school yearbook, *The Jester*, reports that the junior class motto was "not at the top but climbing." Sitting among the students in the front row, second from the right, is Quincy Damon Gasque, Warren County High School principal, and later superintendent of the Warren County school system.

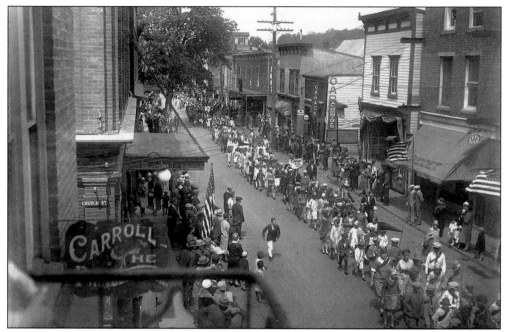

The County Commencement Parade was an eagerly-anticipated annual event. Pictured here are the Waterlick and Front Royal district students of 1927. The day was marked by speeches and entertainment and concluded with the commencement parade. Students and teachers marched from the courthouse down Main Street, each school featuring its own banner. After the parade, students were treated to a movie at the Opera House, visible in the left portion of the photograph.

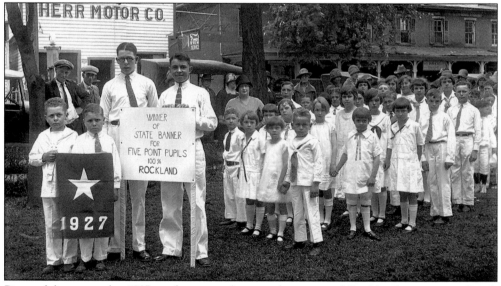

Pictured here are the 1927 students, teachers, and parents of Rockland posing on South Royal Avenue. The students proudly display a banner, featuring a five-point star. The banner represented their participation and high performance in a state-sponsored public school program called the Five-Point Program of Child Health. All of Rockland's students received certificates that year for meeting healthy standards in weight, vision, dental, and hearing.

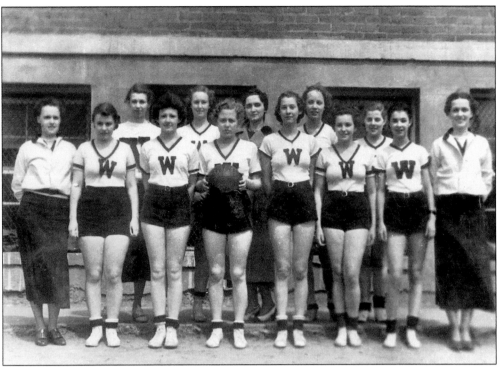

Warren County High School has offered basketball programs for both males and females throughout the majority of the school's history. The members and coaches of the Warren County High School girl's basketball team posed enthusiastically for this 1930s team photograph.

The Front Royal Colored School was built in 1932. The building, consisting of seven classrooms, an office, and a library, was located on the south side of Criser Road. It was one of 25 schools operating in Warren County in 1932, and one of three schools open to African-American students.

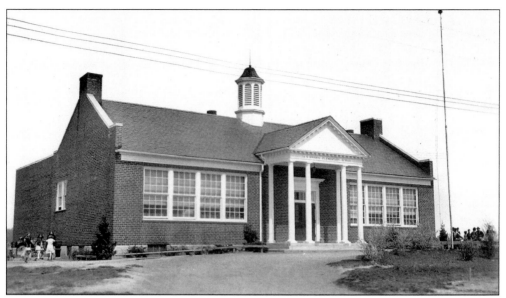

A.S. Rhodes Elementary School, located in Riverton, was dedicated in 1936 and named after the former school board member responsible for the consolidation school building program. "This school building will be the loveliest spot in the lives of many children," commented Mrs. Leslie Fox Keyser, a Warren County educator, who was serving as the supervisor of rural education. Attending the school were 240 local children.

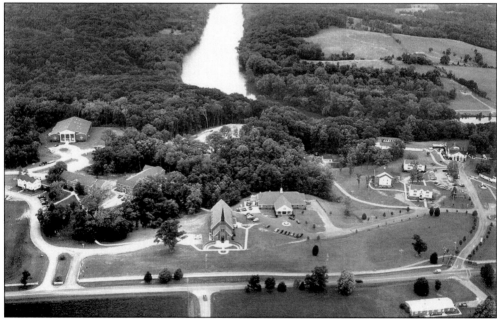

Christendom College is a small, Roman Catholic, four-year liberal arts college located near Front Royal. The college was established in 1977 on a 100-acre campus along the Shenandoah River and dedicated in 1979. Today the college has grown to serve more than 500 students from 44 states and 4 foreign countries and has an endowment of more than $6 million. This modern photograph of the campus shows the chapel in the center, the student union on the right, and the gymnasium in the building with the two crosses, on the left

Nine

AT YOUR SERVICE

All communities thrive on providing citizens with basic services. Front Royal and Warren County are no different from other places in this regard. The most important service arrived with the early settlers in the form of books. Although schools were still a dream, people shared their books with neighbors and the eventual result was library service. The threat and presence of fire has always been a sad reality. As soon as it was practical, a group of firefighters was organized in the 19th century. The 20th century saw the founding of the garden clubs that work tirelessly to keep our town and county fresh and green. The Warren Heritage Society is also crucial to the educational services of Front Royal and Warren County. Today it has grown to include not only a central museum, Ivy Lodge, but local treasures, including Belle Boyd Cottage, the Laura Virginia Hale Archives, and Balthis House, as well.

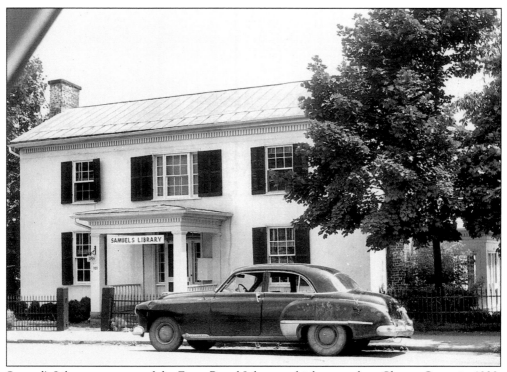

Samuel's Library grew out of the Front Royal Library, which opened on Chester Street in 1920. In 1952, Samuel's Public Library moved to Ivy Lodge, located at 101 Chester Street. The library outgrew these accommodations in the late 1970s and moved to Villa Avenue in 1980.

Samuel's Library has a collection of over 80,000 volumes and a staff of 14. The library offers videos, books on cassette, CD books, newspapers, magazines, and internet service.

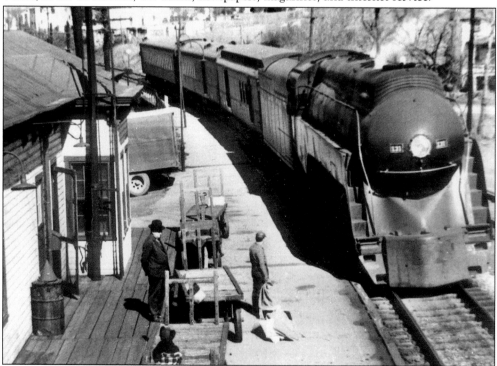

The last passenger train arrived at Front Royal's Main Street Rail Road Station in 1955. The train master, Rufus Purdum, is standing on the platform on the left.

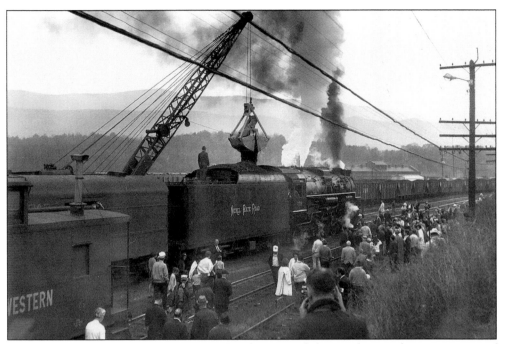

The last steam engine to arrive in Front Royal witnessed the conclusion of over a century of railroad service. Trains continue to come through the area but are centered in the Virginia Inland Port facility.

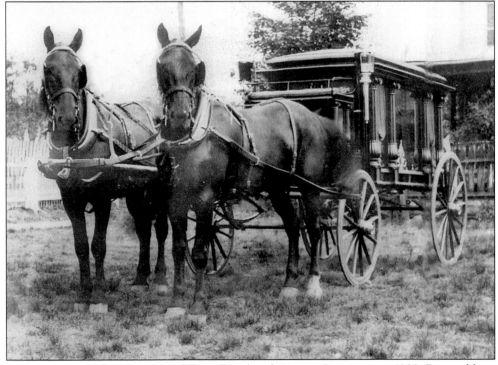

Maddox Funeral Home has served Front Royal and Warren County since 1908. Pictured here is a funeral flower wagon. The horses were named Bob and Joe.

Tree and flower beds in Front Royal and Warren County are an interest of the Beautification Committee. The ladies shown here represent the garden clubs of Warren County, South River Valley, and Front Royal. From left to right are the following: (seated) Irene Mabry, Kaye Messenger, and Judith Wordsworth; (standing) Eleanor Haller, Dede Mains, Peggy Thompson, Louise La Barca, and Ruth Sullivan. This year, 1983, the committee planted 493 trees.

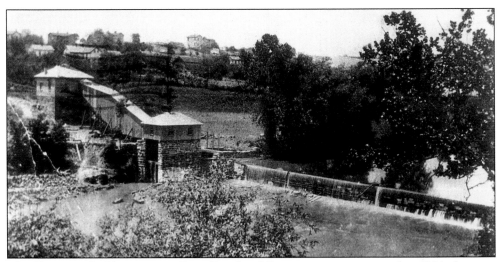

The Electric Light Plant, serving Front Royal and Riverton, was constructed in 1904, the same year telephone service came to Front Royal.

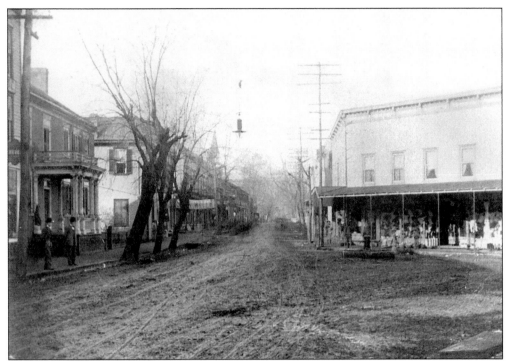

Taken in 1906, this photograph is one of the earliest of Main Street. The shot looks west from the intersection of Main and Chester Streets. The church steeple on the left is that of the Murphy Theater.

This photograph, which appeared on an early 1909 postcard, shows the intersection of Chester and Main Streets.

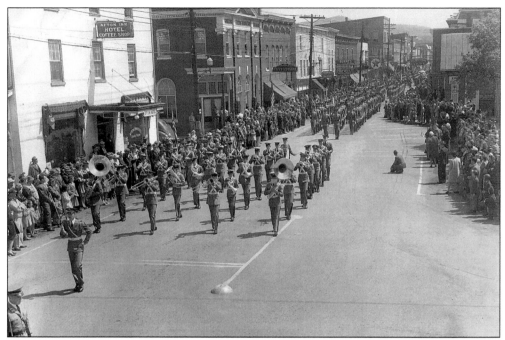

This more recent photograph of Main Street shows the Randolph-Macon Academy band approaching the Afton Inn and Courthouse Square. The image was taken by Margaret Clem.

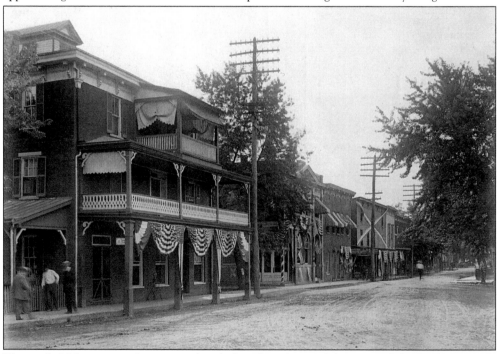

This early 20th-century photo was taken before the advent of the automobile, for the veranda on the Afton Inn remained intact. The porches were badly damaged by an automobile enthusiast who lost control of his vehicle. The damaged front of the inn was not repaired but merely taken off the building.

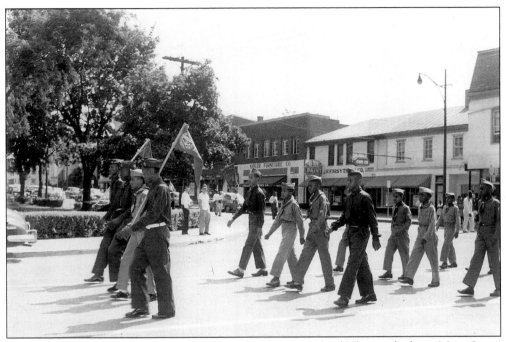

An African-American Boy Scout Troop marches in a Fourth of July parade down Main Street and turning on Chester Street.

This photograph displays a 1995 Festival of Leaves parade on Main Street, during which time Kimberly Jenkins was Little Miss Warren County.

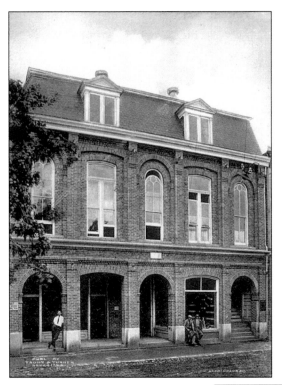

The post office in the Murphy Building is pictured in 1910. The first post office was opened by Alexander Compton in Cedarville in 1805. In 1848, Gideon Jones became the postmaster in Front Royal, a position he held until the outbreak of the Civil War.

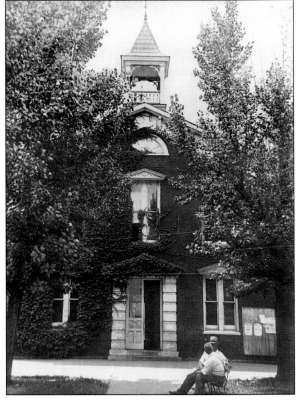

Warren County was formed in 1836 from the southeastern part of Frederick County and the northeastern part of Shenandoah County. The court was held for the first time in a local tavern, and the courthouse was constructed in 1836. This photograph of the courthouse was taken in 1921.

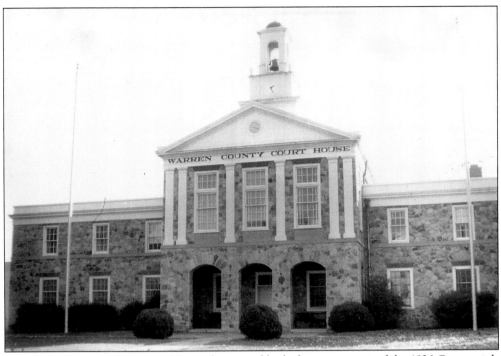

Warren County tore down the old courthouse and built this one as part of the 1936 Centennial.

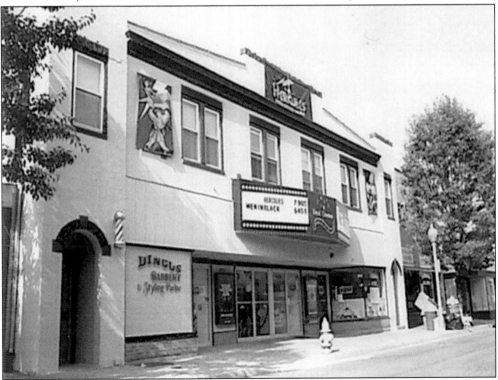

The Park Theater, now the Park Theater and Royal Cinema, is located on Main Street and is a popular place for families.

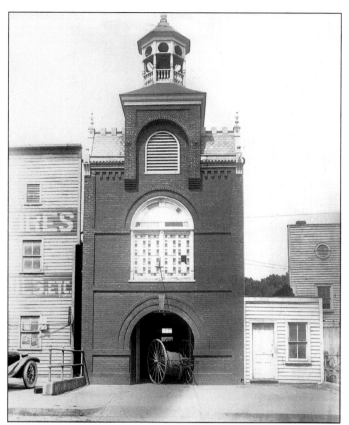

The volunteer Front Royal Hook and Ladder Company No. 1 was organized in 1887, when Front Royal's first fire truck was purchased. Forty-nine men volunteered to serve.

These 1888 volunteers look more like Hessian soldiers than they do members of the volunteer fire company.

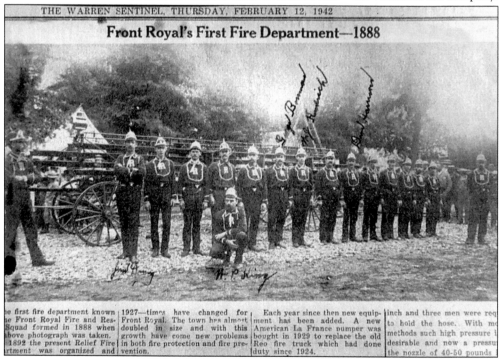

THE WARREN SENTINEL, THURSDAY, FEBRUARY 12, 1942

Front Royal's First Fire Department—1888

e first fire department known e Front Royal Fire and Res- Squad formed in 1888 when 1892 the present Relief Fire rtment was organized and

1927—times have changed for Front Royal. The town has almost doubled in size and with this growth have come new problems in both fire protection and fire prevention.

Each year since then new equipment has been added. A new American La France pumper was bought in 1929 to replace the old Reo fire truck which had done duty since 1924.

inch and three men were req to hold the hose. With me methods such high pressure i desirable and now a pressu the nozzle of 40-50 pounds

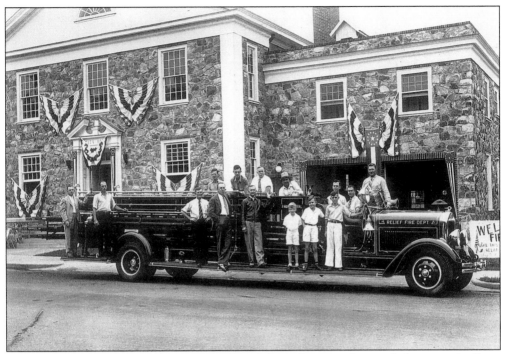

As part of the Centennial of 1936, Front Royal dressed its new fire truck for a parade. From left to right are the following: (front row) Fred Thrush, Clarence Striker, Lewis Thompson, unidentified, Hugh Reid, unidentified, John Stoutamyer, and unidentified; (back row) Ward Myers, Francis Forbes, G. Marchi, Striker, Frank Stoutamyer, Johnny Marchi and John Williams. (Courtesy of Jane W. Vaughan.)

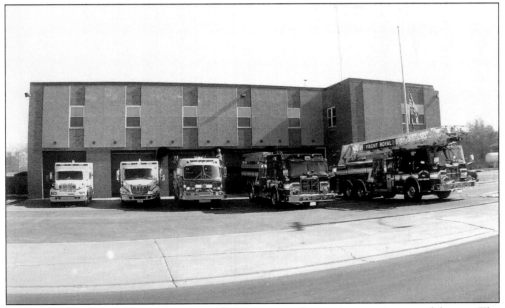

Front Royal is constantly working to make certain its fire equipment is state-of-the-art. The ladder truck in the rear of the picture was purchased in 2003. Other equipment includes ambulances and pumper trucks. The photograph was taken by Phillip Charles.

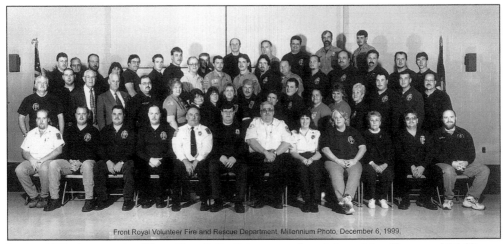

Front Royal Volunteer Fire and Rescue Department, Millennium Photo, December 6, 1999.

In this 1999 photograph of Front Royal's firefighters are, from left to right, (front row) M. Kisner, J. Neal, M. Showers, G. Foster, H. Kisner, L. Oliver, R. Fieldhouser, M. Williams, M. McMurry, R. Franken, J. Starcher, and unidentified; (middle row) P. Charles, R. Sealock, S. Hammock, W. Turner, unidentified, T. Kisner, A. Blankenship, D. Lillard, P. Vendinthal, T. Brogan, P. Kenny, C. Brogan, C. Roberts, D. Rickard, C. Jones, T. Lupton, and E. Bundy; (back row) J. Poe, J. Wren, B. Kresge, M. Starcher, E. McMurry, unidentified, B. Pugh, H. Robinson, B. Waited, B. Feldhauser, M. Smeltzer, R. Miller, unidentified, George, R. Vickers, B. Long, R. Cross, R. Santmyers, R. Smith, R. Cromer, H. Ryan, D. Waited, and C. Nichols. The photograph was taken by Phil Charles.

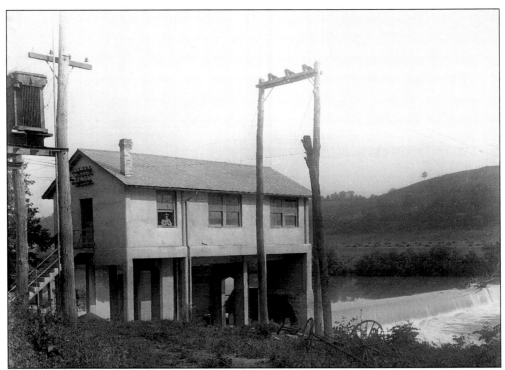

This photograph illustrates the power plant in Riverton before 1928. The Shenandoah River Dam is on the right. This power plant was destroyed in the Flood of 1943.

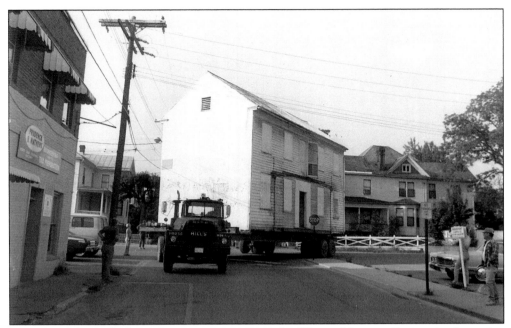

Custody of the Belle Boyd Cottage was given to the Warren Heritage Society in the spring of 1982. The cottage was subsequently moved from its original location, behind the Fishback Hotel (now Second Chance), to its new home behind Ivy Lodge on Chester Street. Many local residents came to watch the procession move across Main Street and down Chester.

Pictured here is Belle Boyd's birthday party on May 8, 1993, attended by Courtney Wood, pictured on the left, and Christine Malson-Ruckman. Tours of the cottage are provided by the staff and include a Christmas 1862 tour, offered in November and December, as well as a tour pertaining to Belle Boyd and the Battle of Front Royal, offered throughout the rest of the year.

Laura Virginia Hale Archives was constructed by the Warren Heritage Society in 1986 and was named for Miss Hale in 1987. The major collections include the papers of local historians such as Laura Virginia Hale, Rebecca Good, Rebecca Poe, and Dickinson. It also boasts a large collection of local newspapers, the *Warren Sentinel*'s photographs, papers of prominent families, the Carl Thompson slide collection, and a number of ledgers from local businesses.

Laura Virginia Hale (1911–1985) was the spirit behind the Warren Heritage Society's Archives. Her papers are among those most frequently requested by local historians. Though she was afflicted by polio as a young girl, which resulted in a complete loss of function in her hands, she was determined to conduct local historical research and wrote with her mouth. In spite of her handicaps, Miss Hale wrote two major volumes on local history: *Four Valiant Years in the Lower Shenandoah Valley, 1861–1865* (1968) and *On Chester Street* (1985).

Student docent Nicole Kahler is one of the Warren Heritage Society's tour guides for Belle Boyd Cottage. She often appears in parades and at local historical events as Belle Boyd. Here she is writing her famous thank you letter to Gen. Stonewall Jackson after the Battle of Front Royal.

After the Stokes Furniture Store and a large number of adjoining buildings burned in 1969, Front Royal decided to rehabilitate the area and designed a much needed park and parking area. In the lower left portion of the image is the old railroad station, which is now the Visitors Center. In the center is the gazebo, which is directly across Main Street from Second Chance, formerly the Fishback or the Strickler Hotel. Historic Chester Street is adjacent to Main Street on the right.

In 1975 the old Remount Station was purchased by the Smithsonian Institute and developed into the National Zoological Park Conservation Center. The center serves as a breeding ground for endangered species. One of the favorite species currently housed at the center is the Golden Marmoset, pictured here.

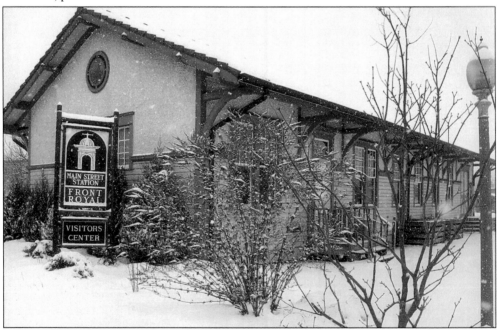

The Front Royal Visitors Center is located on Main Street, open from 9:00 a.m. to 5:00 p.m., seven days a week, and is the point of departure for the driving tour of the Battle of Front Royal. This state-certified building provides information on the National Park and a host of other local and regional places of interest. It also houses a souvenir shop and bookstore.